Chineasy™

ノ 人 人 人

# Chineasy™

## THE NEW WAY TO READ CHINESE

by SHAOLAN 曉嵐

with illustrations by NOMA BAR

HARPER
DESIGN
An Imprint of HarperCollinsPublishers

CHINEASY: THE NEW WAY TO READ CHINESE. Copyright © 2014 Chineasy Ltd.

The story on pages 159–179 is based on Prokofiev's *Peter and
the Wolf* (1936)

Chineasy™ is a trademark of Chineasy Ltd, London

Published by arrangement with Thames & Hudson Ltd, London.

First published in North America in 2014 by
Harper Design
*An Imprint of* HarperCollins*Publishers*
10 East 53rd Street,
New York, NY 10022
Tel: (212) 207-7000, Fax: (212) 207-7654
harperdesign@harpercollins.com
www.harpercollins.com

Distributed in North America by
HarperCollins*Publishers*
10 East 53rd Street,
New York, NY 10022
Fax: (212) 207-7654

Library of Congress Control Number: 2013951753

ISBN 978-0-06-233209-7

Third printing, April 2014

Author and Concept: ShaoLan Hsueh 薛曉嵐
Graphic Design: Brave New World Publishing Ltd
Art Director: Crispin Jameson
Principal Illustrator: Noma Bar

Printed and bound in China by Hung Hing Off-set Printing Co. Ltd

# CONTENTS

一 one (yī)
This is the first stroke
taught to children.
It means 'one'.

# 1

## INTRODUCTION

The Calligrapher's Daughter
How to Use the Book

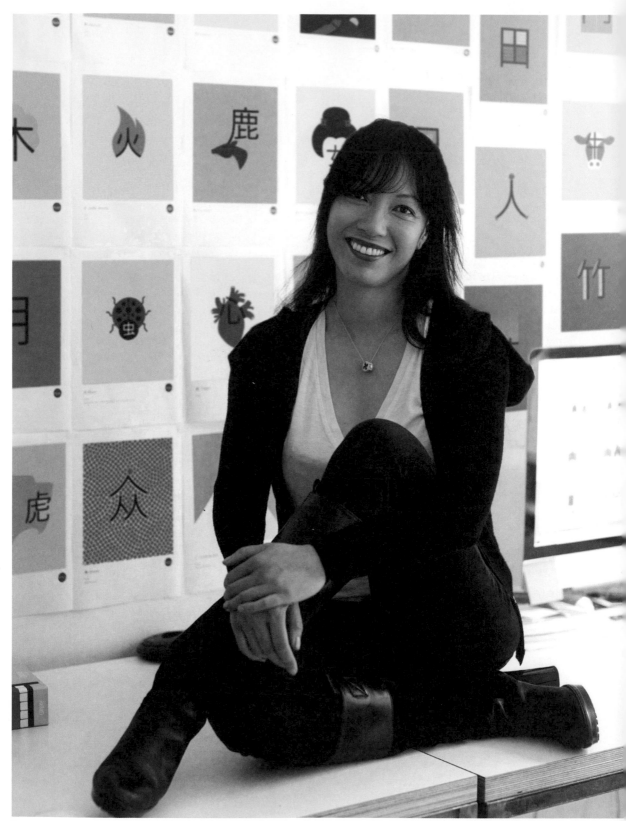

# The Calligrapher's Daughter

I was born in Taipei, Taiwan, the daughter of a calligrapher and a ceramic artist, so I grew up immersed in art and with a deep appreciation of the beauty of the Chinese language. Speaking and writing Chinese is an integral part of who I am and how I see the world. But it was only when I had children of my own that I properly understood what a difficult language Chinese is to learn.

Being of Taiwanese descent while raising my children in the UK has made me acutely aware of the differences, but also the similarities, between Eastern and Western cultures. The ultimate goal of Chineasy is to help bridge the cultural gap by demystifying the Chinese language, which acts as a barrier to so many people – my children included!

Chineasy is hugely personal to me. I have done many different things in my life. I consider myself to be part geek, part entrepreneur, part dreamer, and this project is a culmination of all these elements. My experience in technology ventures and my background as an entrepreneur with an artistic upbringing have given me the building blocks to make Chineasy possible, but it is my childhood and my children that have inspired me to make Chineasy a reality. I am proud to share Chineasy with all who want to learn and appreciate the beauty of the Chinese language.

## Why Chineasy?

China is home to ancient traditions, breathtaking artwork and what is currently one of the world's strongest economies. It comes as no surprise to me that recent years have seen a cultural trend of Eastern migration by both young people and business-minded individuals. Everyone is starting to pay more attention to China, Taiwan, Japan, South Korea and other Asian countries as they become increasingly popular tourist destinations and increasingly important as cultural, financial and industrial hubs.

Call me optimistic, but I see the melding of these two cultures, East and West, as being instrumental in creating a more culturally literate world. I also think that the East and West must understand each other in order for global economic growth to be sustainable. There is, however, a giant roadblock preventing the East and West from communicating effectively and connecting on a deep, cultural level: the Great Wall of Chinese.

The Chinese language has long been considered the most difficult major language to learn, largely on account of the vast number and complexity of the characters. When I began to teach my British-born children Chinese, I realized just how challenging its characters are for a native English speaker. It was like torture for my children! So I spent many years looking for a fun and easy way to teach them how to read Chinese.

After years of searching, I didn't think that any of the methods out there were engaging enough. So I did what any entrepreneur would do: I created my own method to learn how to read Chinese characters – Chineasy. And you know what? It works.

Chineasy's goal is to allow people to learn to read Chinese easily by recognizing characters through simple illustrations. The magical power of the Chineasy method is that, by learning one small set of building blocks (see p. 10), students can build many new characters and phrases. Master a few sets of building blocks, and your learning can be accelerated to a whole new level.

With very little effort, students can quickly learn to read several hundred Chinese characters and phrases, and gain a deeper understanding of the historical and cultural references of the vocabulary. Even though there are tens of thousands of Chinese characters, only a few hundred are actually necessary to comprehend basic Chinese literature, and to begin to delve into Chinese culture and art.

# How to Use the Book

## A quick overview

Each character in this book is introduced in its Chinese form, followed by its English translation and then its pinyin (the approximate sound of the character; see p. 13). Each building block and compound character (these terms are explained below) has a short introduction that teaches you some fun historical and cultural facts as you are learning the language. Also included are unillustrated phrases (e.g. see 'heart' on p. 87) that will help to expand your vocabulary.

At the end of the book there is a handy index that lists every character and phrase taught in Chineasy, and provides you with its traditional and simplified forms (see opposite) and its pinyin.

## Chineasy methodology

The Chinese language is traditionally taught through a series of between roughly 180 and 215 radicals. These radicals are then used to form the characters of the Chinese language. Chineasy has broken down this collection of characters into their most basic and recurring forms, allowing students to learn fewer and simpler radicals that we have termed 'building blocks'.

One building block (e.g. the character 火 for 'fire', see p. 28), or a specific compound form of the building block (e.g. 灬 'fire', see p. 28), can be combined with one or more other characters to make a compound character (e.g. 炎 'burning hot', see p. 29). Two or more independent characters can be placed next to one another to make phrases (e.g. 炎炎 'blazing', see p. 30). In compounds, a whole new character is created; in phrases, the placement of characters next to one another gives a new meaning to the collection of characters. This principle of building blocks is what makes Chineasy so easy!

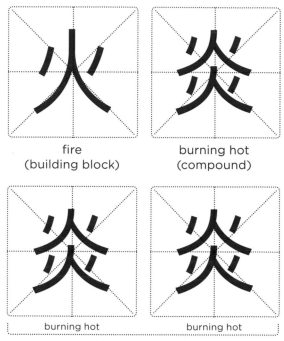

fire
(building block)

burning hot
(compound)

burning hot    burning hot

blazing (phrase)

## Traditional or simplified?

Chineasy teaches mainly traditional Chinese, which is the written language of Taiwan and Hong Kong. Simplified Chinese was adopted in mainland China in 1949, after the end of the Chinese Civil War and the establishment of the People's Republic of China. Both traditional and simplified forms still share a great number of characters. Chineasy specifies in the character captions when the simplified form is used instead of the traditional form (e.g. 'to follow' and 'crowd' on p. 17). Where no distinction between forms is noted, the traditional and simplified forms of the character are the same.

## The evolution of Chinese

As in the case of all languages, Chinese has continuously evolved throughout the course of its existence. Political change, geographic expansion and philosophy have all influenced the stylistic form of Chinese characters. Throughout the book, you will see references to oracle-bone 甲骨文 (c. 1400 BCE), bronze script 金文 (c. 1000 BCE), seal script 篆書 (c. 220 BCE) and clerical script 隸書 (c. 200 BCE) characters. These terms refer to periods in the evolution of Chinese writing from which the modern Chinese language is derived.

The most ancient Chinese characters were developed as logograms, and therefore do not usually indicate how they should be pronounced (see p. 13). However, as the Chinese language became more sophisticated, two or more building blocks were used to form new characters; in this case, one of those building blocks was chosen as the basis for the new character's pronunciation. For example, account/bill 賬 (zhang⁴) on p. 85 comprises the building block for 'shell' (associated with wealth – see p. 130), indicating the meaning of the compound character, and the character for 'length' (chang²), which influences the pronunciation. (See also 'at' on p. 115.)

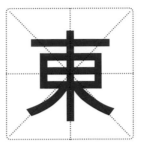

'sun' in oracle bone

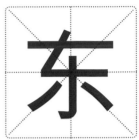

'sun' in seal script

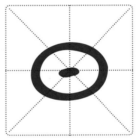

'east' in traditional Chinese

'east' in simplified Chinese

'sun' in clerical script

'sun' in modern Chinese

## Writing 101

Every child who studies Chinese has to go through this exercise when they learn how to write. Each character has to be drawn neatly inside a square. You can see that a single tree fits into a square the same size as the squares used for 'two trees' and 'three trees'.

You should see a slight alteration of the shape from the original 'tree': in order to fit two trees side by side in the square, you must make thinner trees. When three trees are stacked together, all the trees are shorter in order to fit into the square.

In Chinese, certain building-block characters have an alternate form that appears only when used as part of a compound. These characters are traditionally known as 'pianpang' 偏旁. On the right, you can see an example of this in the 'person' 人 = 亻 compound form in the compound 'group' 伙. Other examples of this alternate character form can be seen in 'dog' 犬 = 犭 on p. 26 and 'fire' 火 = 灬 on p. 28. Such compound forms are indicated by a note under the main caption for the building block.

See p. 35 for more information about writing Chinese.

Even though there are several different spoken Chinese dialects, such as Mandarin or Cantonese, they all share the same written characters; it is only the pronunciation of these characters that will differ from one dialect to another – often completely.

The 'pinyin' pronunciation guide used in this book corresponds to Mandarin only, which is the most widely used Chinese dialect and counts over 960 million native speakers (out of a total of over 1.2 billion Chinese speakers) – see 'Speaking 101' opposite for more information about pronunciation.

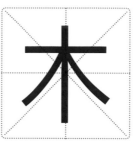

tree

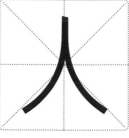

person

two trees = wood

person compound form

three trees = forest

group

## Spacing 101

How can you tell if you are reading a character (字) or a phrase (詞)? A character, whether it's a building block or a compound, fits within one square.

When you see two people squeezed together in a single square, you know it's a character – for example, the simplified character 'to follow' 从.

A phrase, on the other hand, is spaced across two or more squares. That means, if you see two or more characters spread across two or more squares, then you know it's a phrase – for example, 'everyone' 人人.

The beauty of the Chineasy method is that you can construct many new 'words' by combining existing characters. Chinese characters rarely appear alone; it is often only in the context of a phrase that the meaning of a character becomes clear. Learning phrases is a giant but easy step towards improving your Chinese study.

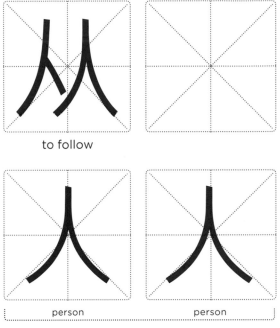

to follow

person        person

everyone

## Speaking 101

To teach Mandarin Chinese to non-native speakers, most teachers use pinyin, the only standard phonetic system for transcribing the sound of Chinese characters in the romanized alphabet. Chinese is a tonal language, so the pinyin system uses a series of either numerals or glyphs to represent tone. For instance, the pinyin for 'person' can be written as either ren[2] or rén. Chineasy uses the numerical pinyin system. After every English translation, you will see a word in brackets followed by a number; this acts as a guide to the pronunciation of the character. See, for example, p. 16 人 person (ren[2]).

Tone 1 = high level tone
Tone 2 = high rising tone
Tone 3 = falling rising tone
Tone 4 = falling tone
No number = neutral tone

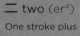 two (er[4])

One stroke plus
another is two.

## 2

## THE BASICS

Building Blocks, Compounds, Phrases
Advanced Sentences

## 人 person (ren²)

Hello, people! Our first building block is 'person'. This building block traditionally depicted a human in profile. Today it looks like the profile of a man walking.

........................................

## 亻 person (ren²)

This character is the form of 'person' that is used as a component in certain compounds (see explanation on p. 12). It is known as **單人旁**, which translates as 'single person side-radical'. See 'group' on p. 29 for an example of this character.

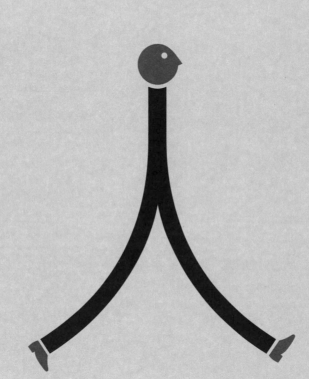

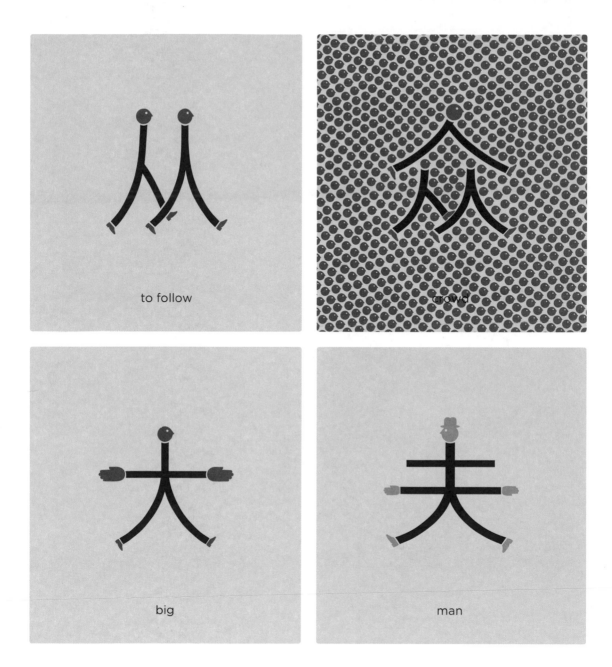

to follow

crowd

big

man

**从 to follow** (cong²)

This character comprises two building blocks for 'person'. One man leads, the other follows close behind. This is the simplified form; the traditional form of this character is 從.

**众 crowd** (zhong⁴)

'Two's company, three's a crowd.' Three building blocks for 'person' make a crowd. This is the simplified form; the traditional form of this character is 眾.

**大 big** (da⁴)

This character depicts a man stretching his arms wide. Imagine that he is saying, 'It was this big.'

**夫 man** (fu¹)

'Man' is the compound for 'big' with an extra line across the top of the character, like wide shoulders. This line represents the pins in a man's topknot hairstyle.

## 大人 adult
(da⁴ ren²)

Height doesn't always indicate maturity, but, in simple terms, an adult is just a big person. big + person = adult

## 大众 public
(da⁴ zhong⁴)

The public is made up of a large group of people. big + crowd = public

## 众人 people
(zhong⁴ ren²)

A crowd is made up of many different people. This phrase also means 'everybody'. crowd + person = people

## 夫人 madam
(fu¹ ren²)

In ancient China, a woman became her husband's property after marriage; she became her husband's person. man + person = madam

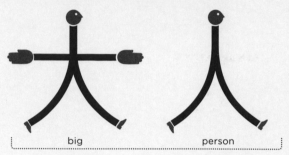

big ..... person

adult

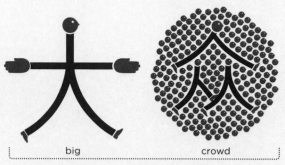

big ..... crowd

public

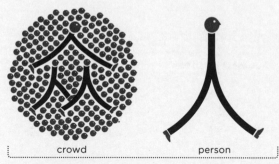

crowd ..... person

people

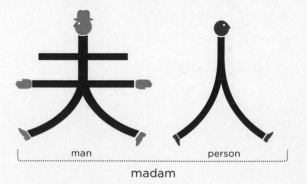

man ..... person

madam

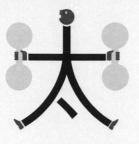

too much

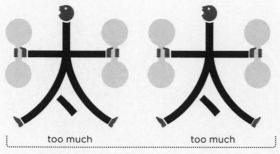

too much        too much

Mrs

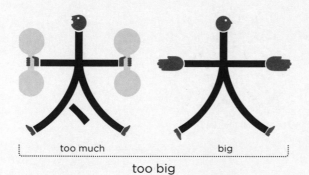

too much        big

too big

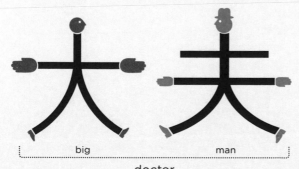

big        man

doctor

### 太 too much (tai⁴)

This compound comprises 'big' and a stroke under the character, suggesting something even bigger. It also means 'extremely' or 'excessively'.

### 太太 Mrs (tai⁴ tai⁴)

This is a strange phrase. To have double too much means 'Mrs' or 'wife'. Do you think this phrase is accurate? too much + too much = Mrs

### 太大 too big (tai⁴ da⁴)

A straightforward phrase: if something is too big, there is too much of it. too much + big = too big

### 大夫 doctor (dai⁴ fu)

This phrase has two meanings. When pronounced 'dai⁴ + fu', with a neutral and soft tone, it means 'doctor'. When pronounced 'da⁴ + fu', it means 'senior official'. Both are rather archaic. big + man = doctor

天 sky (tian[1])

When you put a line on top of 'big' 大, it means 'sky' or 'heaven'. Traditionally, the line represented the spiritual level above man and earth. This character can also mean 'day'.

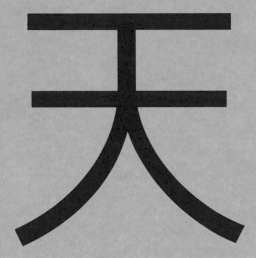

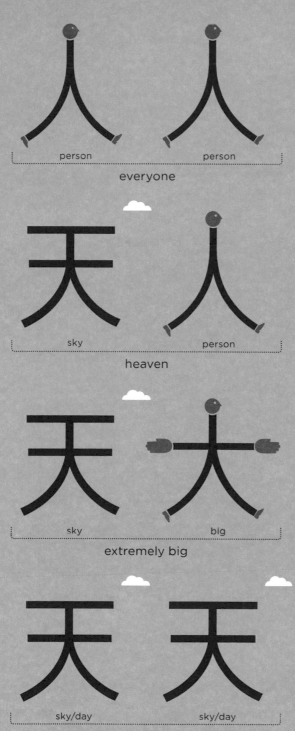

人人 everyone
(ren[2] ren[2])

person + person =
everyone

天人 heaven
(tian[1] ren[2])

sky + person = [literally]
sky person = heaven or
a person with universal
insight

天大 extremely big
(tian[1] da[4])

What could be a bigger
space than the heavens?
sky + big = [literally] big
as the sky = extremely big

天天 every day
(tian[1] tian[1])

As we have already seen
opposite, the character
for 'sky' also means 'day'.
day + day = every day

## 口 mouth (kou³)

Depending on the size of the building block, this character means either 'mouth' (if it is small) or 'to surround' (if it is large).

································································

## 口 to surround (wei²)

Can you tell the difference between these two characters? It is nearly impossible, but the difference is usually made evident by the meaning of the compound. It's useful to remember that 'to surround' never appears alone, so if you see a stand-alone 口, it is the character for 'mouth'.

shout

quality

to cause

to return

## 吅 shout (xuan¹)

A mouth emits sound. Two mouths emit even more sound! This is a rare character, so use it to show off to your Chinese friends!

## 品 quality (pin³)

Imagine that each mouth is an opinion. The quality of something is judged by what people say about it. This character also means 'item', 'product' or 'grade'.

## 因 to cause (yin¹)

This character is a combination of 'mouth' and 'big'. It also means 'because of' and 'reason'. I like to remember it by thinking that a big mouth causes problems (although, in this case, 口 means 'to surround').

## 回 to return (hui²)

This character is a combination of a small 'mouth' and 'to surround'. Imagine that it depicts a swirling whirlpool, continuously turning back on itself.

## 人口 population
(ren² kou³)

When we start counting how many mouths we need to feed, we are talking about population. person + mouth = population

## 人品 morality
(ren² pin³)

Remember, it is always wise to judge the quality of a person on the basis of their morality. person + quality = morality

## 回人 Hui people
(hui² ren²)

'Hui' is used to refer to Chinese speakers of Muslim ancestry. They are one of the fifty-six recognized ethnic groups in China. to return + person = [literally] returned people = Hui people

## 人魚 mermaid
(ren² yu²)

In ancient China, this phrase referred to the giant salamander. Today it means 'mermaid'. person + fish = [literally] fish person = mermaid

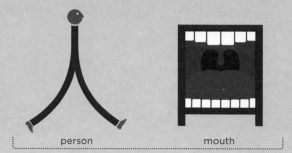

person · mouth

population

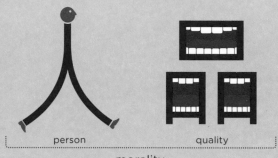

person · quality

morality

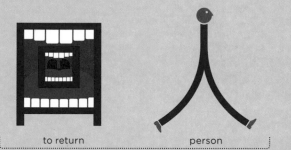

to return · person

Hui people

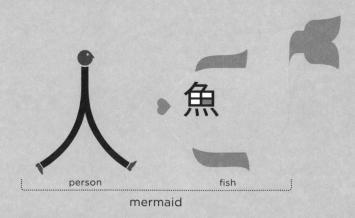

person · fish

mermaid

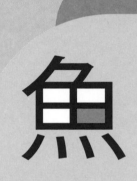

魚 fish (yu²)

Traditionally a fish shape in oracle-bone and seal inscriptions, this character originally referred to 'an aquatic vertebrate', but has since been extended to mean 'fish'. Its simplified form is 鱼.

犬 dog (quan³)

The regular form of this character is 'big' 大 with an additional dot on the upper right side. The earliest form in oracle-bone inscriptions was a drawing of a dog, with the extra stroke representing its tail.

犭 dog (quan³)

This character is the form of 'dog' that is used as a component in certain compounds. See 'to stroll' on p. 113 for an example.

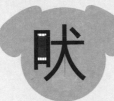 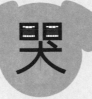 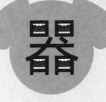

to bark          to cry          utensil

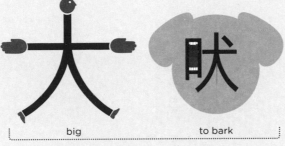

big                    to bark

to bark loudly

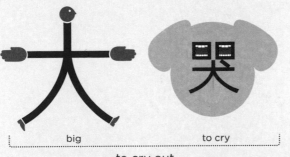

big                    to cry

to cry out

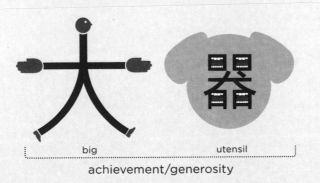

big                    utensil

achievement/generosity

吠 **to bark** (fei⁴)

This character is a combination of 'mouth' and 'dog'. When a dog opens its mouth to emit a sound, it is barking.

哭 **to cry** (ku¹)

This character is a combination of 'dog' and two 'mouth' building blocks. As the crying sound of a human sounds similar to the whine of a dog, this character means 'to cry'.

器 **utensil** (qi⁴)

This character is a combination of 'dog' and four 'mouth' building blocks. It can also mean 'instrument'.

大吠 **to bark loudly** (da⁴ fei⁴)

big + to bark = [literally] big bark = to bark loudly

大哭 **to cry out** (da⁴ ku¹)

This phrase can also mean 'to burst into tears'. big + to cry = [literally] big cry = to cry out

大器 **achievement/ generosity** (da⁴ qi⁴)

This phrase can also mean 'great talent'. big + utensil = [literally] big utensil = achievement

**火 fire** (huo³)

The building block for 'fire' represents a central flame with a smaller spark on either side. It reminds me of a campfire. I like to remember this character by thinking about a person waving their arms, saying, 'Help! I'm on fire!'

**灬 fire** (huo³)

This character is the form of 'fire' that is used as a component in certain compounds. When you see a compound with this character, it is normally related to fire or something hot. See 'lamb' on p. 41 for an example of this character.

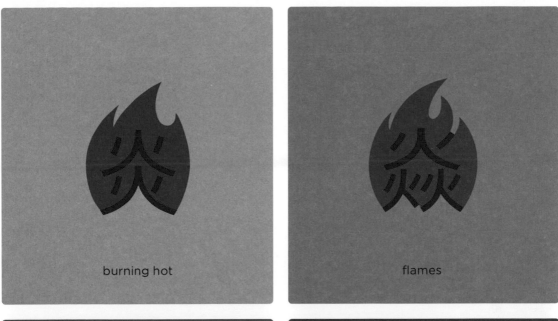

burning hot

flames

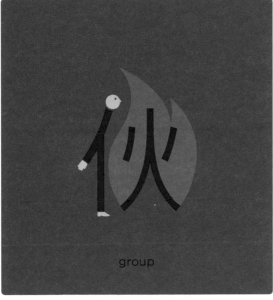

group

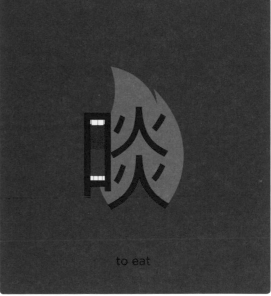

to eat

**炎 burning hot** (yan²)

This compound comprises two 'fire' building blocks stacked on top of each other. They are burning twice as hot as before. This character also means 'inflammation'.

**焱 flames** (yan⁴)

The building block for 'fire' represents one flame. Multiply that by three and you have a roaring fire.

**伙 group** (huo³)

In ancient China, fires were used mainly for cooking and for warmth. When people gathered around the fire, they were considered to be part of the group.

**啖 to eat** (dan⁴)

This character is a combination of 'mouth' and 'fire'. It means 'to eat' or 'mouthful'. Chinese food, especially food from Sichuan Province, can be very spicy, like a fire in your mouth as you eat.

## 炎炎 blazing
(yan² yan²)

A blazing fire burns with incredible heat. You see this character used to describe weather, e.g. 'blazing summer' 炎炎夏日. burning hot + burning hot = blazing

## 焱焱 flames of fire
(yan⁴ yan⁴)

This phrase might seem redundant, but there are different types of flame, such as flames of passion. flames + flames = flames of fire

## 大伙 folks
(da⁴ huo³)

In ancient China, to light the fire meant that it was time to cook. People who would gather around the fire to eat together were 'partners', 'mates' or 'companions'. big + group = folks

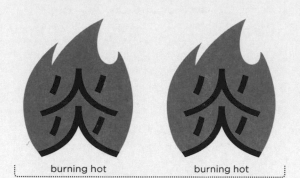

burning hot      burning hot

blazing

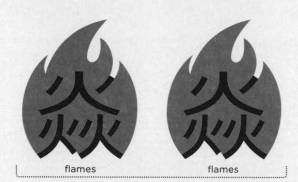

flames      flames

flames of fire

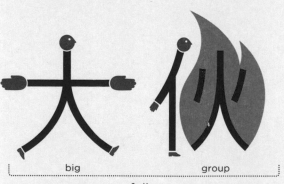

big      group

folks

# A lesson in burning anger!

Fire (火) is one of the five elements in traditional Chinese medicine. Each person is born with a unique composition of all five elements; it is this unique blend of elements that forms the basis of your personality and constitution. The 'qi' (vital force) of the five elements waxes and wanes in daily and seasonal cycles. The theory behind Chinese medicine is that a person becomes sick owing to an imbalance of these elements.

Practitioners of traditional medicine believe that when there is an imbalance of the fire element, it results in a person suffering from anxiety, restlessness and insomnia. So the element of fire is associated with a person's temper. Theoretically, when a person's fire accumulates, so does the person's temper. They become angry!

## 火大 angry
(huo$^3$ da$^4$)

When a person burns with rage, we can assume that they are angry. This is quite an informal term. fire + big = angry

## 大火 big fire
(da$^4$ huo$^3$)

A very simple phrase. big + fire = big fire

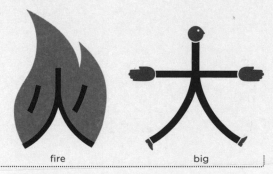

fire      big

angry

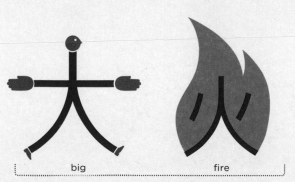

big      fire

big fire

木 tree (mu⁴)

The building block for 'tree'
represents a tree trunk
with hanging branches.
When this character is
used as an adjective, it
refers to a wooden texture.
When it is used to describe
a person, it means 'clumsy',
'dumb' or 'numb'.

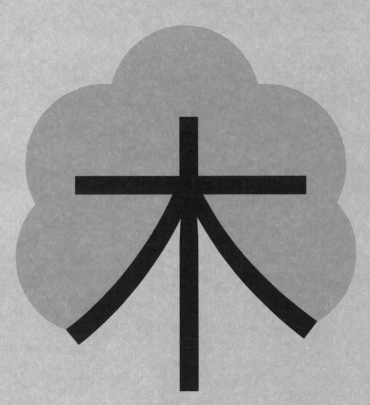

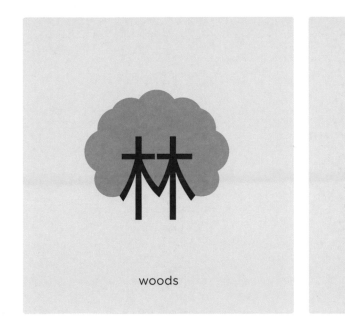

woods

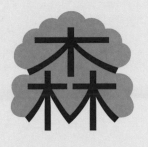

forest

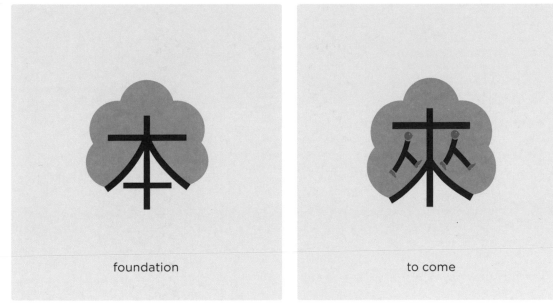

foundation

to come

### 林 woods (lin²)

Two trees together make a wood, which is greater than a single tree. This character is also a common surname, pronounced 'Lin'. It's actually my mother's surname.

### 森 forest (sen¹)

Three trees make a forest, which is greater than a tree or a wood. When used as an adjective, this character means 'dense', just like a thick cluster of trees.

### 本 foundation (ben³)

The foundation of a house is the first step in its construction, and traditionally foundations were made of wood. This character also means 'origin'.

### 來 to come (lai²)

This character is a combination of 'tree' and two 'person' building blocks. In ancient China, 'to come' was represented by a character based on wheat, which had been brought to China from Europe. The simplified form is 来.

## 本來 originally
(ben³ lai²)

origin + to come
= originally

## 本人 one's self
(ben³ ren²)

Remember: a person's
origin often influences
their sense of self.
origin + person = [literally]
person's origin = one's self

## 來人 messenger
(lai² ren²)

Before the age of
electricity, all messages
had to be sent by person.
This is quite an old-
fashioned or poetical
phrase. to come +
person = messenger

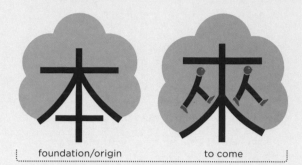

foundation/origin          to come

originally

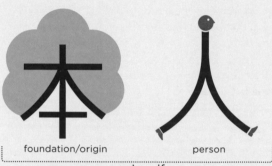

foundation/origin          person

one's self

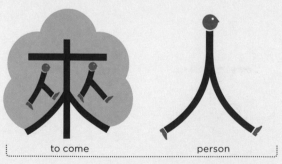

to come          person

messenger

# Four ways furious

Is Chinese written horizontally or vertically? Chinese can be written in either direction. You can read from left to right, right to left, or top to bottom. The only direction you won't find is bottom to top.

Today the most common style is from left to right, in the same way that English, French, Spanish or German are read.

In some ancient literature or on road signs in China, you will sometimes see phrases written from right to left. This can prove to be odd when you have literature that mixes both English and Chinese. I once saw a book cover that had the English title running from left to right and the Chinese title running from right to left!

If you are trying to read vertically (for example, you quite often have to do this if you are reading scrolls), then you would read from right to left, starting with the first vertical line on the right from top to bottom, and then moving towards the left of the scroll.

**本人火大** I am furious
(ben³ ren² huo³ da⁴)

one's self + angry =
[literally] one is angry = I am furious

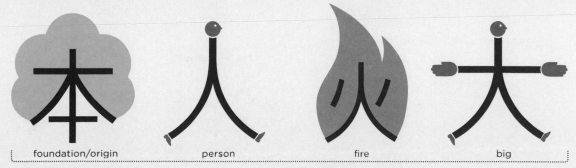

| foundation/origin | person | fire | big |

I am furious

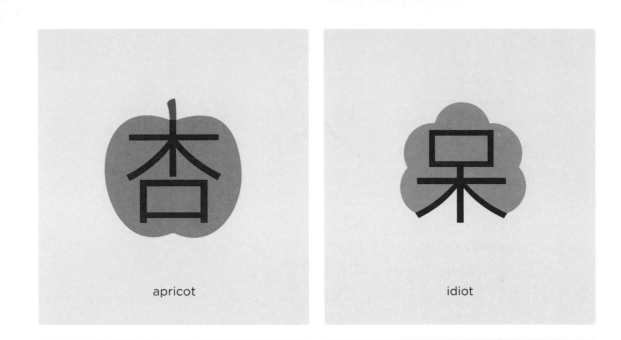

apricot

idiot

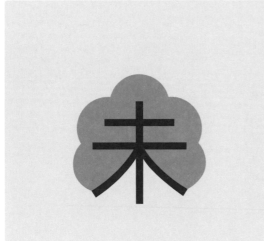

not yet

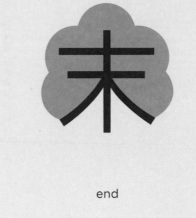

end

杏 apricot (xing⁴)

This character is a combination of 'tree' and 'mouth'. I would wait under a tree with my mouth open to catch an apricot. The character also means 'almond'.

呆 idiot (dai¹)

This character is another combination of 'tree' and 'mouth'. Nothing is more idiotic that the thought of a talking tree! The character also means 'dull'.

未 not yet (wei⁴)

In ancient inscriptions, this character depicted a realistic tree, with leaves and foliage indicating an ever-growing, living tree. The character also means 'future'.

末 end (mo⁴)

It looks as if the topmost branches of this tree have plateaued, Indicating that it has ended its growth. Make sure that the upper line is longer than the lower one!

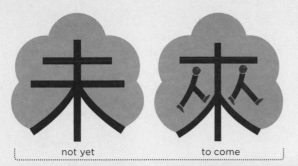

未來 future
(wei[4] lai[2])

not yet + to come = future

未 not yet
來 to come
future

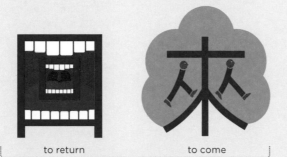

回來 to come back
(hui[2] lai[2])

to return + to come =
[literally] to return from
where you have come =
to come back

回 to return
來 to come
to come back

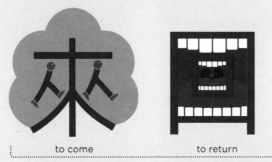

來回 round trip
(lai[2] hui[2])

to come + to return =
[literally] to return to
where you have come =
round trip

來 to come
回 to return
round trip

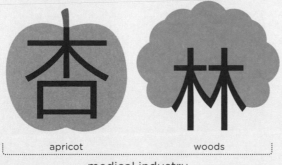

杏林 medical
industry (xing[4] lin[2])

Today it is easy to forget
that all medicine was
once derived from nature,
and made from products
from the forest, such as
fruits, herbs and leaves.
apricot + woods = source
of medicine = medical
industry

杏 apricot
林 woods
medical industry

## 休 rest (xiu[1])

This character is a combination of 'person' and 'tree'. I like to remember it by imagining a person resting against a tree.

## 体 body (ti[3])

This character is a combination of 'person' and 'foundation'. A person's foundation is their body. This is the simplified form; the traditional form is 體.

## 人体 human body (ren[2] ti[3])

person + body = human body

## 大体 in general (da[4] ti[3])

This phrase can be used to mean 'in general', 'more or less' or 'basically'. big + body = in general

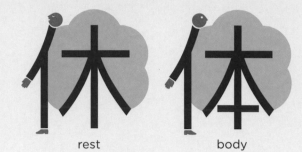

rest      body

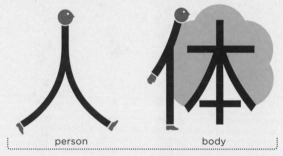

person      body

human body

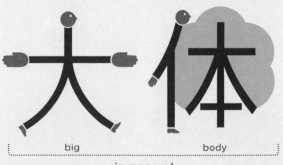

big      body

in general

竹 bamboo (zhu²)

This building block resembles two bamboo stalks with leaves.

笨 stupid (ben⁴)

This character is a combination of 'bamboo' and 'foundation', and also means 'foolish'. Depending on the company you keep, it can be a very useful character. In Chineasy, no student will feel 笨, because Chinese is so easy!

羊 sheep (yang²)

In Chinese, 羊 represents the goat-antelope group of mammals. The context, within a phrase or compound, determines if it refers to a sheep, goat or other animal. If you see 'sheep' in a compound character, it tends to relate to something sheep-like or nice and positive.

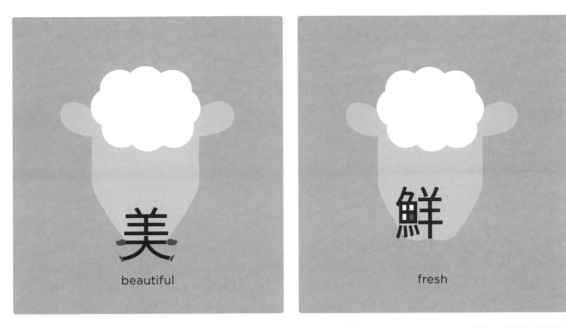

美
beautiful

鮮
fresh

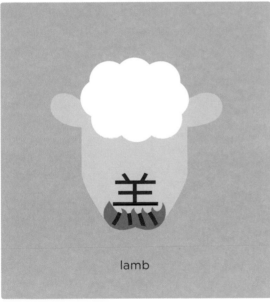

羔
lamb

咩
bleating of sheep

**美 beautiful** (mei³)

This character is a combination of 'sheep' and 'big'. In ancient China, sheep were considered auspicious. This compound is also an abbreviation for the USA (see p. 79).

**鮮 fresh** (xian¹)

This character is a combination of 'fish' on the left and 'sheep' on the right. Originally it referred to a fish breed, but today has been extended to mean 'fresh'.

**羔 lamb** (gao¹)

This character is a combination of 'sheep' and 'fire'. It represents a lamb over a fire, which in certain parts of China would have been how lamb was prepared.

**咩 bleating of sheep** (mie¹)

This character is a combination of 'mouth' and 'sheep', and refers to the sound emitted from a sheep's mouth – 'baa'.

# 山 mountain (shan[1])

The character for 'mountain' represents the peaks of a mountain range.

to get out

to cry out in anger

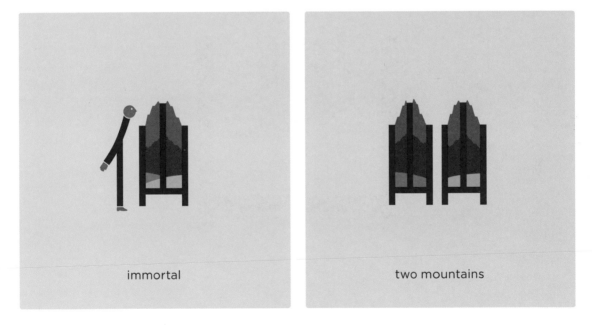

immortal

two mountains

### 出 to get out (chu¹)

In the past, the Emperor sent people in exile beyond the mountains. As a result, this character used to mean 'exit'. Today it means 'to get out'.

### 屾 to cry out in anger (duo¹)

This character is a combination of 'mouth' and 'mountain', and can also mean 'noise of rage'.

### 仙 immortal (xian¹)

This character is a combination of 'person' and 'mountain'. Remember that a man who lives as long as a mountain will appear immortal to other men.

### 屾 two mountains (shen¹)

This compound can either be a surname or refer to two mountains. It's another rare character that you can use to show off to your Chinese friends.



## 出口 exit
(chu¹ kou³)

A mouth that tells you where to get out is an exit. to get out + mouth = exit

## 出來 to come out
(chu¹ lai²)

This is such an easy phrase. to get out + to come = to come out

## 出品 to publish
(chu¹ pin³)

How do you get a product out to the people? You publish it, of course! to get out + product = to publish

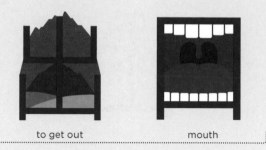

| to get out | mouth |
| --- | --- |

exit

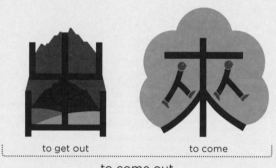

| to get out | to come |
| --- | --- |

to come out

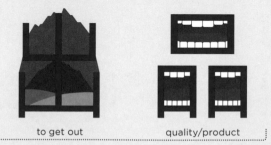

| to get out | quality/product |
| --- | --- |

to publish

## 火山 volcano
(huo³ shan¹)

fire + mountain = volcano

## 火山口 crater
(huo³ shan¹ kou³)

volcano + mouth =
[literally] the mouth
of the volcano = crater

## 休火山 dormant volcano
(xiu¹ huo³ shan¹)

rest + volcano = [literally]
at rest volcano = dormant
volcano

fire     mountain

volcano

fire     mountain     mouth

crater

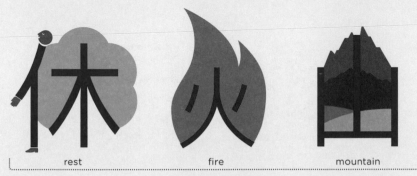

rest     fire     mountain

dormant volcano

**女 woman** (nu³)

This character traditionally depicted an outline of a woman kneeling on the floor, showing her obedience to a man. I am very frustrated by the origin of this character! When used as an adjective, it means 'female'.

# Why two women together means 'argument'

Sadly, it seems that when women are together, they quarrel. The character showing two women together represents 'argument'. This meaning is a product of Chinese history.

In the old days, it was inevitable that women in Chinese households ended up arguing. For hundreds of years, Chinese married couples lived together with their parents-in-law and the rest of their extended family. It was not unusual for four generations to live under the same roof. And sometimes mothers-in-law took revenge on their daughters-in-law for 'stealing' their sons. It was also common practice for wealthy Chinese men to have several wives (for example, my great-grandfather, who was a landlord in Taiwan, had three). To make sure that their own sons would inherit the lion's share of their husband's wealth, mistresses and wives sometimes ganged up on the newest concubines that their husbands brought home. No wonder that domestic conflict was often the norm!

By now you may have noticed that, in Chinese, a character rarely appears by itself. You often need to add another character in order to clarify the meaning in different contexts. Many phrases are constructed by repeating a character. On the next page, you will learn that 妹 means 'younger sister'. In real life, you will more frequently see 妹妹 (where 妹 is repeated) to express 'younger sister'. This is very common practice in the Chinese language; see the example on p. 156. The meaning of the phrase is made absolutely clear by repeating the character. Other examples you will see in this book are 人人 ('everyone', p. 21), 天天 ('every day', p. 21), 白白 ('in vain', p. 63), 媽媽 ('mama'; see 'mother', p. 77) and 公公 ('grandfather'; see 'public', p. 141).

As in the case of many English words, a character may have different meanings depending on whether it is used as a noun, a verb or an adjective. For example, 女 is 'woman', but when talking about 'a woman', you will more frequently see the phrase 女人 (p. 49), where 女 is the adjective 'female' and 人 is the noun 'person'.

Another example is 'forest'. The character 森 on its own means 'forest' (p. 33), but when we talk about 'a forest', we often use the phrase 森林 (p. 156), where 森 is the adjective 'forest-like' used to describe the noun 林 'woods'.

A final example is 'tomorrow'. The character 明 can mean 'bright', 'brightness' or 'tomorrow' (p. 57). But you more frequently see the phrase 明日 used to refer to 'tomorrow' (p. 59), where 明 is used as an adjective to describe the noun 日 'day'.

妌 argument (nuan[2])

Traditionally, two women were believed to be unable to be in the same room without arguing.

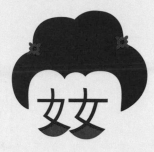

姦 adultery (jian[1])

Any man with three women is cheating on someone.

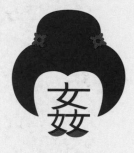

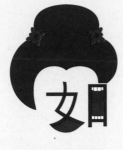

to obey

younger sister

daughter

greed

**如 to obey** (ru²)

This character is a combination of 'woman' and 'mouth'. A woman in ancient China didn't speak her own opinions, she obeyed. This compound also means 'is like' (see p. 65) and 'if' (see 'to forgive', p. 87).

**妹 younger sister** (mei⁴)

This character is a combination of 'woman' and 'not yet', so the literal translation is 'not yet a woman'. It is used to refer to a younger sister.

**囡 daughter** (nan¹)

This character is a combination of 'woman' and 'to surround'. Young girls were traditionally kept in their family homes, surrounded by their family, to protect their modesty for their eventual marriage.

**婪 greed** (lan²)

This character is a combination of 'woods' and 'woman'. It also means 'a great number' or 'a lot'. 'A lot of woman' means 'greed' – that's so negative!

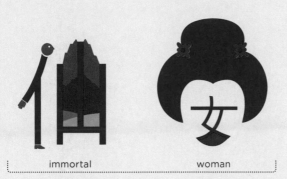

immortal       woman

fairy

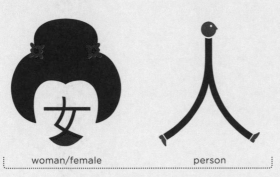

woman/female       person

woman

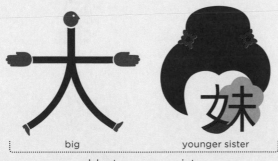

big       younger sister

eldest younger sister

### 仙女 fairy (xian¹ nu³)

Of all the mythical immortals, fairies are most associated with women. immortal + woman = fairy

### 女人 woman (nu³ ren²)

A female person is a woman. woman/female + person = woman

### 大妹 eldest younger sister (da⁴ mei⁴)

Family hierarchy was extremely important in ancient China. Authority was based on age and sex. Men ruled the family hierarchy in age order, continuing with the women from eldest to youngest. The second youngest sister in the family would therefore be one above the lowest-ranking member of the family. big + younger sister = [literally] big younger sister = eldest younger sister

 **bird** (niao³)

In oracle-bone and
seal inscriptions, this
character depicted a bird.
The modern character
represents a bird with four
talons and a hanging tail
feather. The simplified form
of this character is 鸟.

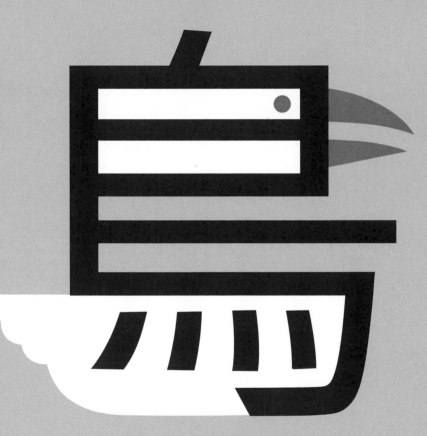

羽 feather (yu³)

I think it is obvious that this character looks a lot like a feather!

# 日 sun (ri⁴)

In oracle-bone and seal inscriptions, the character for 'sun' was a circle with a dot in the middle. It has since evolved to look very similar to a Western window. This character also means 'day'.

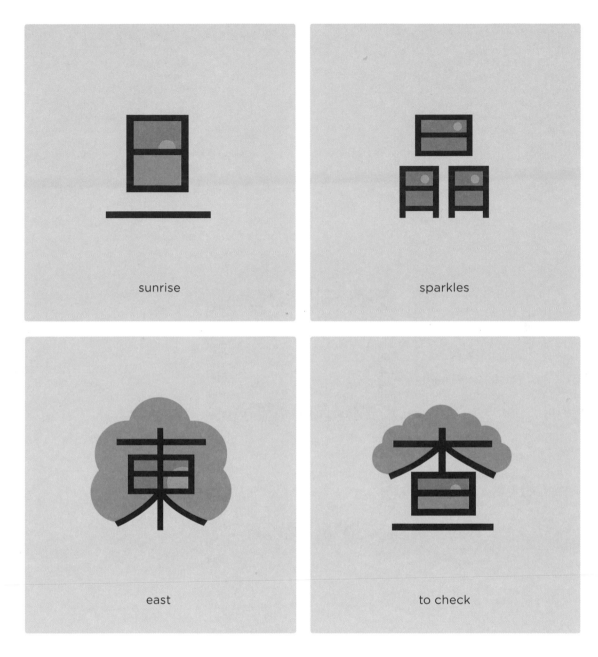

sunrise

sparkles

east

to check

**旦 sunrise** (dan⁴)

This is an easy compound to remember, as it depicts the sun rising above the line of the horizon.

**晶 sparkles** (jing¹)

The old form of 'sparkles' was written as three circles, two on the bottom and one on top, and meant 'brilliant' or 'glittering'.

**東 east** (dong¹)

This character is a combination of 'tree' and 'sun'. The sun rises in the East, and a man would have first glimpsed the sun through the trees. The simplified form is 东.

**查 to check** (cha²)

The original meaning of this character was 'raft'. To check and explore what lies beyond the horizon, you need a raft of some sort.

## 山東 Shandong Province
### (shan[1] dong[1])

Shandong is the name of a province on the east coast of China. It has a population of 96 million people, and is one of the most important cultural areas of China. It is the historic centre for Taoism and the birthplace of Confucius. Its name 山東, 'east of the mountains', comes from the province's location to the east of the Taihang Mountains.

## 山東人 person from Shandong Province
### (shan[1] dong[1] ren[2])

east of the mountains + person = [literally] person from east of the mountains = person from Shandong Province

## 山東女人
## woman from Shandong Province
### (shan[1] dong[1] nu[3] ren[2])

east of the mountains + woman = [literally] woman from east of the mountains = woman from Shandong Province

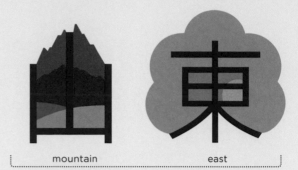

mountain      east

Shandong Province

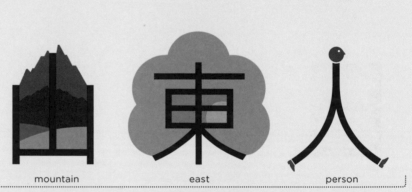

mountain      east      person

person from Shandong Province

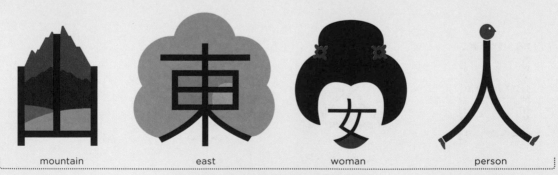

mountain      east      woman      person

woman from Shandong Province

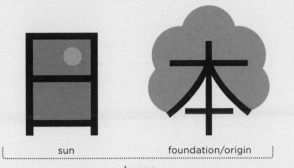

sun               foundation/origin

Japan

### 日本 Japan
(ri[4] ben[3])

Japan is known as the 'land of the rising sun' in English. Japan lies to the east of China, which is where the sun rises.
sun + origin = [literally] origin of the sun = Japan

### 日本人
**Japanese person**
(ri[4] ben[3] ren[2])

Japan + person = Japanese person

### 日本女人
**Japanese woman**
(ri[4] ben[3] nu[3] ren[2])

Japan + woman = Japanese woman

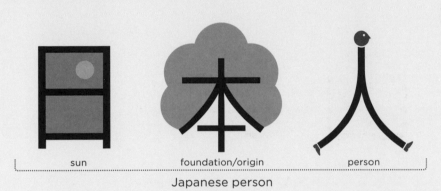

sun         foundation/origin         person

Japanese person

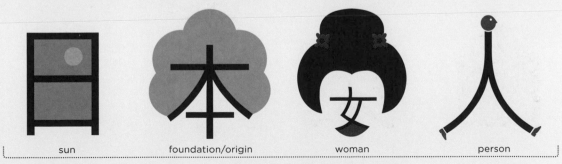

sun       foundation/origin       woman       person

Japanese woman

## 月 moon (yue[4])

The building block for moon originally derived from a pictogram of the crescent moon. It has now evolved to be a visual counterpart to 'sun'. This character also means 'month'.

## 肉 = 月 flesh (rou[4])

The building block for 'flesh' (or 'meat') 肉 looks almost identical in its compound form to 'moon'. Can you tell the difference between the two characters? It is nearly impossible, but the difference is usually made evident by the meaning of the compound. If you see 肉 or 月 as part of a character on a restaurant menu, it is likely to refer to some part of an animal – although not necessarily a part that you would like to eat.

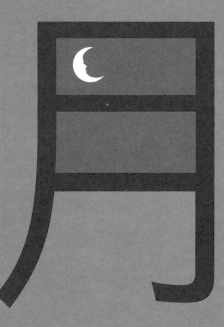

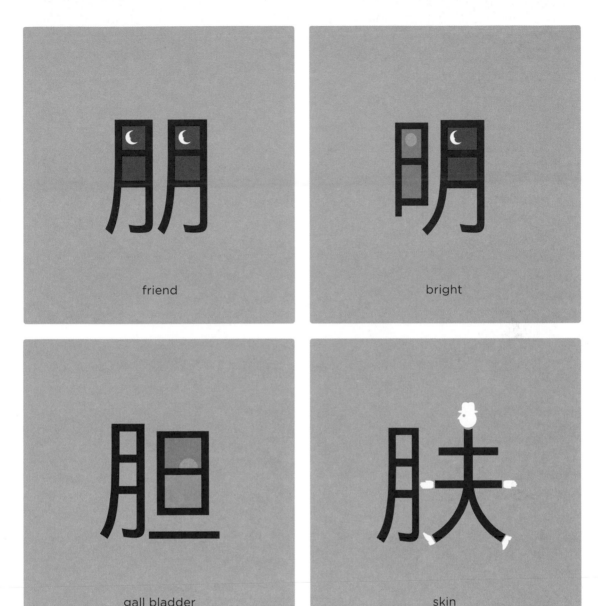

friend

bright

gall bladder

skin

### 朋 friend (peng²)

In oracle-bone inscriptions, this character depicted two bunches of shells, which were used at the time as a form of currency.

### 明 bright (ming²)

When the sun and moon shine together, it creates a character meaning 'bright' or 'brightness'. This character also means 'tomorrow'; see the explanation on p. 47.

### 胆 gall bladder (dan³)

This character is a combination of 'flesh' and 'sunrise'. This is the simplified form; the traditional form is 膽. Both forms can also mean 'courage'.

### 肤 skin (fu¹)

This character is a combination of 'flesh' and 'man'. A man's flesh is his skin. This is the simplified form; the traditional form is 膚.

## 查出 to find out
(cha² chu¹)

to check + to get out =
[literally] to check out =
to find out

## 查明 to ascertain
(cha² ming²)

to check + bright =
[literally] to clarify what
you check = to ascertain

## 來日 in the coming
days (lai² ri⁴)

The building block for
'sun' can also double as
the character for 'day'.
to come + day = in the
coming days

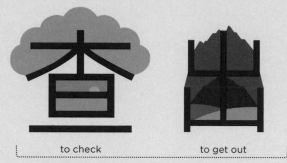

to check — to get out

to find out

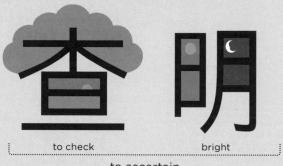

to check — bright

to ascertain

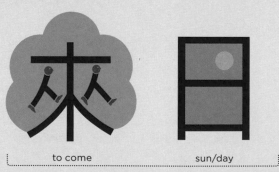

to come — sun/day

in the coming days

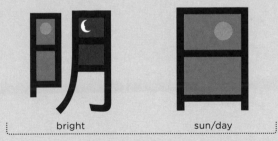

bright · sun/day

**tomorrow**

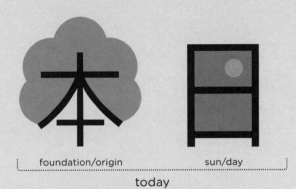

foundation/origin · sun/day

**today**

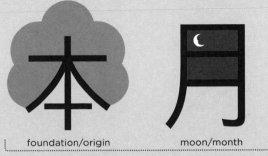

foundation/origin · moon/month

**this month**

明日 tomorrow
(ming[2] ri[4])

Remember, after a day and a night comes tomorrow. bright + day = tomorrow

本日 today (ben[3] ri[4])

origin + day = today

本月 this month
(ben[3] yue[4])

Just as the 'sun' building block can also mean 'day', so the 'moon' building block can also mean 'month'. origin + month = this month

工 work (gong[1])

In oracle-bone inscriptions, this character was depicted as a tool shape, and its original meaning was 'holding a tool' or 'carpenter's square'. Today it has been extended to mean 'work', 'labour' or 'skill'. Compounds that use this character include:

左 left (zuo[3])
右 right (you[4])
巫 wizard (wu[1])

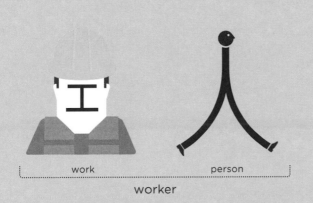

work · person

worker

工人 worker
(gong[1] ren[2])

work + person = [literally]
working person = worker
or labourer

人工 artificial
(ren[2] gong[1])

person + work = [literally]
person's work = man-made
= artificial

女工 female worker
(nu[3] gong[1])

woman + work =
[literally] woman's work
or needlework = female
worker

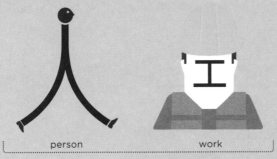

person · work

artificial

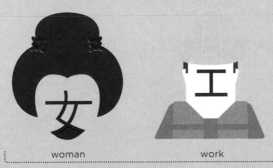

woman · work

female worker

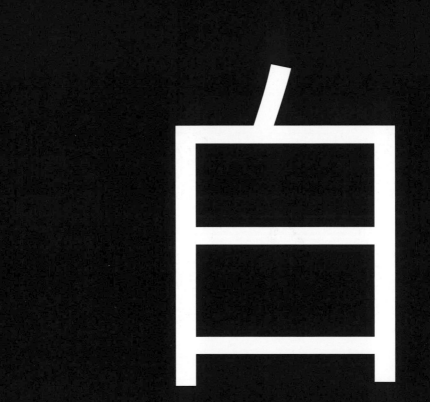

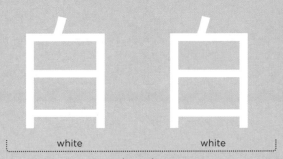

white          white

in vain

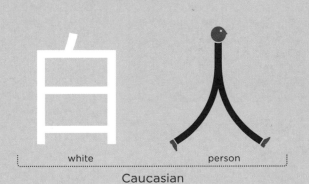

white          person

Caucasian

白 天

white          sky/day

daytime

### 白白 in vain
(bai² bai²)

white + white =
in vain/for no purpose

### 白人 Caucasian
(bai² ren²)

An alternative but
derogatory word for
Caucasian is 'gweilo',
which means 'ghost person'.
white + person = [literally]
white man = Caucasian

### 白天 daytime
(bai² tian¹)

The character for 'sky'
can also mean 'heaven'
or 'day'. In this instance,
it means 'day'.
white + day = daytime

### 習 to learn/practise
(xi²)

This character is a
combination of 'feather'
and 'white'. It generally
refers to learning to fly.
Its simplified form is 习.

虎 tiger (hu³)

The building block for
'tiger' also means 'brave'
or 'fierce'.

·····································

唬 to scare (hu³)

This character is a
combination of 'mouth'
and 'tiger'. Imagine how
scared you would be to
hear a tiger roar in the
middle of the night.

虎

# Tiger idioms

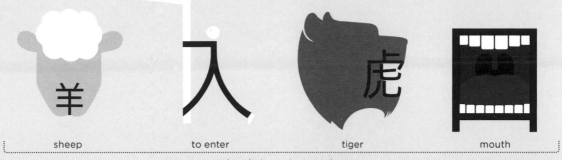

| sheep | to enter | tiger | mouth |
|---|---|---|---|

a lamb in a tiger's den

羊入虎口 is a famous Chinese idiom that means 'a lamb in a tiger's den'. The phrase is a warning against entering a dangerous environment and becoming a victim as a result. You will notice that the second character, 入 'to enter' (ru⁴), looks similar, to 人 'person', but its meaning is totally different. The slight difference is in the length of the strokes. The right stroke of 'to enter' is longer than that of 'person'.

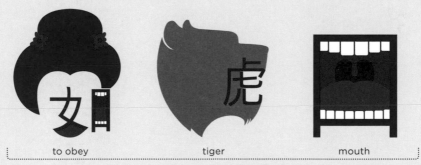

| to obey | tiger | mouth |
|---|---|---|

as dangerous as a tiger's den

In this phrase, 如 'to obey' means 'is like', while 虎口 means 'tiger's den'. The phrase means 'as dangerous as a tiger's den'. If you see this phrase, keep your wits about you. An extension of this phrase, 馬路如虎口 'the crossroad is like the tiger's den', is also seen at road crossings to remind people to be careful when crossing the road.

門 door (men[2])

The building block for
'door' looks very similar
to a pair of saloon doors
from the Wild West. Saloon
doors may be a much more
recent invention, but the
resemblance is uncanny!
The simplified form is 门.

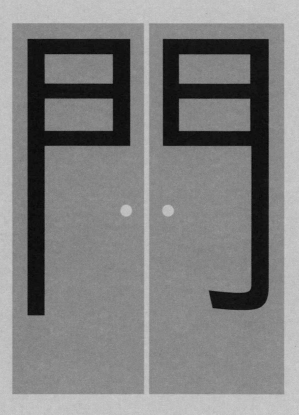

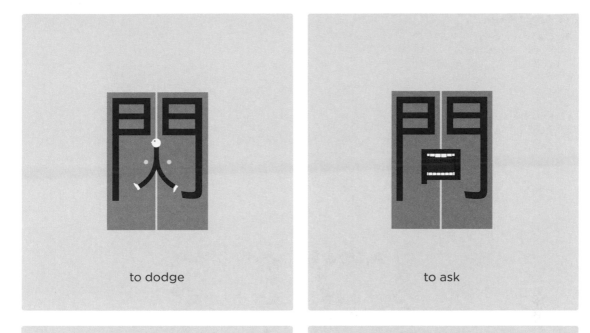

to dodge

to ask

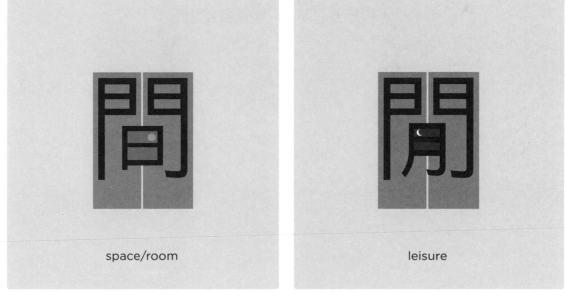

space/room

leisure

### 閃 to dodge (shan³)

Imagine a person running through a pair of saloon doors, trying to dodge arrest. This character also means 'flash'. The simplified form is 闪.

### 問 to ask (wen⁴)

This character is a combination of 'door' and 'mouth'. To ask a question is the door to knowledge. The simplified form is 问.

### 間 space/room (jian¹)

This character is a combination of 'door' and 'sun'. In seal script this character was identical to 閒 'leisure', so it was changed to prevent confusion. The simplified form is 间.

### 閒 leisure (xian²)

Before electricity, all work stopped when darkness fell and the moon rose. This character also means 'idle', 'peaceful' or 'calm'. Alternative forms are 閑 and 闲.

## 大門 front gate
(da[4] men[2])

big + door = [literally]
big door = front gate

## 門口 doorway
(men[2] kou[3])

door + mouth = [literally]
door's mouth = doorway

## 大門口 main entrance
(da[4] men[2] kou[3])

big + doorway = [literally]
big doorway = main entrance

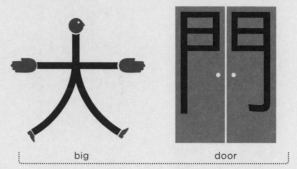

big          door

**front gate**

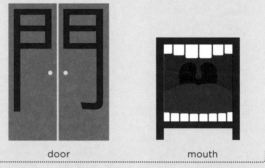

door          mouth

**doorway**

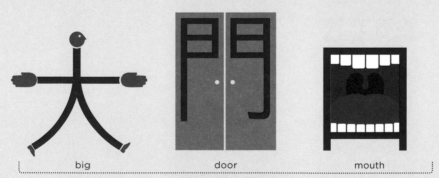

big          door          mouth

**main entrance**

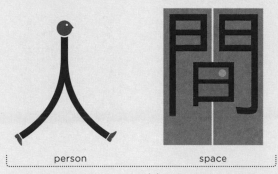

person    space

world

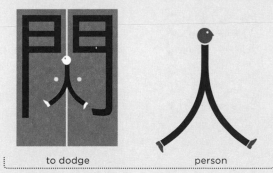

leisure    person

idler

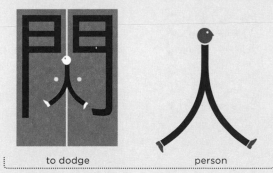

to dodge    person

to sneak out

人間 world
(ren² jian¹)

person + space = [literally]
the space for people = world

閒人 idler
(xian² ren²)

leisure + person = idler

閃人 to sneak out
(shan³ ren²)

to dodge + person =
[literally] person dodging =
to sneak out

## 水 water (shui³)

The building block for 'water' looks like a winding river, with streams entering into it on either side.

. . . . . . . . . . . . . . . . . . . . . . . . . . . . . . . . . .

## 氵 water (shui³)

This character is the form of 'water' that is used as a component in certain compounds. It is commonly known as 三點水, 'three dots of water'. See 'plain' opposite for an example of this character.

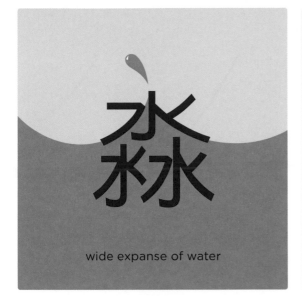

wide expanse of water

foam

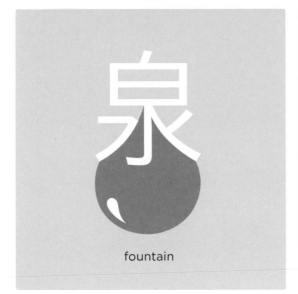

fountain

plain

淼 **wide expanse of water** (miao³)

This character comprises three 'water' building blocks. It is logical that multiple waters would be used to describe a large amount of water.

沫 **foam** (mo⁴)

This character is a combination of 'water' and 'end'. Just remember that foam is the last form of water as it crashes on to the shore.

泉 **fountain** (quan²)

This character is a combination of 'white' and 'water'. It also means 'spring'. Remember that fresh spring water often comes from melting snow, which is white.

淡 **plain** (dan⁴)

This character is a combination of 'water' and 'burning hot'. It also means 'light', 'bland', 'modest', 'essential' or 'tasteless'.

江 river (jiang¹)
water + work

汝 you (ru³)
water + woman

沐 to bathe (mu⁴)
water + tree

淋 to drip (lin²)
water + woods

## 水晶 crystal
(shui³ jing¹)

In this phrase, the 'water' building block alludes to the clear nature of water.
water + sparkles = crystal

## 口水 saliva
(kou³ shui³)

mouth + water = saliva

## 淡水 fresh water
(dan⁴ shui³)

This is also the name of a town in the north of Taipei County, Taiwan.
plain + water = fresh water

## 淡月 quiet month for business
(dan⁴ yue⁴)

A typical 淡月 in China is July, which is Ghost Month in the Chinese calendar. In Asia, Ghost Month is an annual month of ancestor worship, with some similarities to the Western Halloween.
light + month = [literally]
light month = slack month = quiet month for business

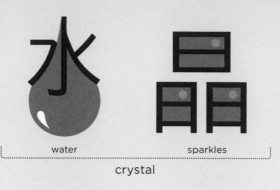

water      sparkles

crystal

mouth      water

saliva

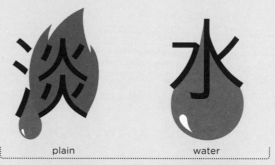

plain      water

fresh water

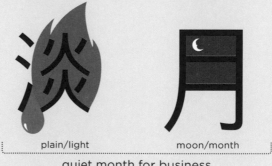

plain/light      moon/month

quiet month for business

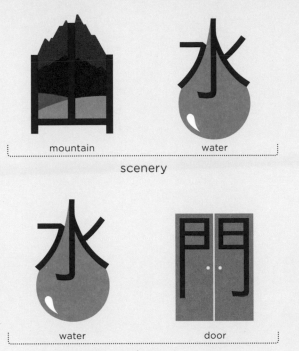

mountain      water

scenery

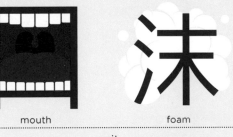

water      door

dam

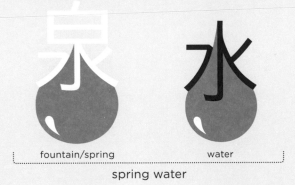

mouth      foam

spit

fountain/spring      water

spring water

### 山水 scenery
(shan¹ shui³)

The majority of scenery comprises spectacular mountains and vast rivers, for example, Mount Fuji in Japan, Mount Huangshan in China or Ha Long Bay in Vietnam, to name a few!
mountain + water = scenery

### 水門 dam
(shui³ men²)

This phrase was used to describe the Watergate scandal of the 1970s. It is a literal translation of the English name given to the scandal that resulted in President Nixon's resignation.
water + door = [literally] water gate = dam

### 口沫 spit
(kou³ mo⁴)

mouth + foam = [literally] mouth foam = spit

### 泉水 spring water
(quan² shui³)

spring + water = spring water

## 牛 cow (niu[2])

The original meaning of this character was 'ox', but since the clerical change in writing styles it has meant 'cow'. If you see 'cow' in a character, it tends to relate to stubbornness.

.............................................................

## 牛 cow (niu[2])

This character is the form of 'cow' that is used as a component in certain compounds.

## 水牛 buffalo
### (shui³ niu²)

The water buffalo with a large crescent horn is a major domestic animal used in southern China for paddy cultivation.
water + cow = [literally] water cow = buffalo

## 天牛 longhorn beetle
### (tian¹ niu²)

The longhorn beetle is black with small white spots resembling the stars in a night sky.
sky + cow = [literally] sky cow = longhorn beetle

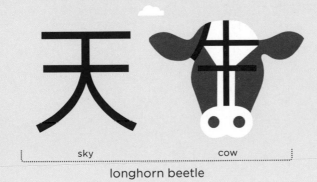

water ⌐‾‾‾‾⌐ cow

buffalo

sky ⌐‾‾‾‾⌐ cow

longhorn beetle

# 馬 horse (ma³)

This building block traditionally looked like a horse on its side. Today you can see only the horse's torso, tail and legs. The simplified form is 马.

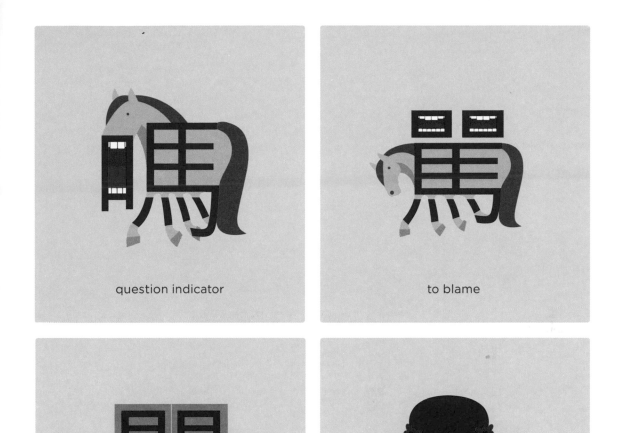

question indicator

to blame

to charge in

mother

**嗎 question indicator (ma²)**

This character is a combination of 'mouth' and 'horse'. It is used at the end of a sentence to indicate that a 'yes' or 'no' answer should follow. The simplified form is 吗.

**罵 to blame (ma⁴)**

This character is a combination of 'shout' and 'horse'. It means 'blame', 'abuse', 'curse' or 'scold' when used as a verb. The simplified form is 骂.

**闖 to charge in (chuang³)**

Pictographically, this character represents a horse charging through a door. The simplified form is 闯.

**媽 mother (ma¹)**

This character is a combination of 'woman' and 'horse'. 媽媽 means 'mama'. The simplified form is 妈.

# 玉 jade (yu⁴)

Throughout Asian history, jade has been more prized than silver and gold both monetarily and spiritually. The building block for 'jade' comprises a bottom stroke representing earth, a top stroke representing heaven, and a middle stroke representing heaven's essence on earth. In simplified Chinese, 'jade' and 'king' are both classified as radicals. In some characters, the 'jade' 玉 building block does not take the extra dot, and so appears as 'king' 王. See 'whole' opposite for an example.

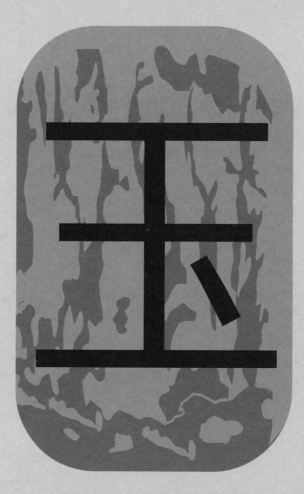

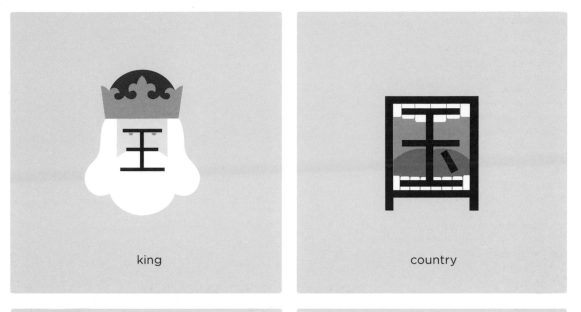

king

country

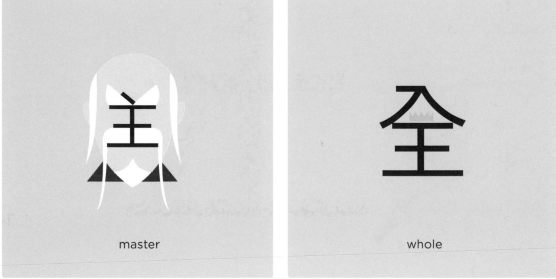

master

whole

王 king (wang²)

Traditionally more prized than silver and gold, jade was worn by kings and nobles throughout Asian history, and represented the virtues of beauty, grace and purity.

国 country (guo²)

This character is a combination of 'jade' and 'to surround'. China is the country of jade, so it is logical that the country is alluded to as the 'land of jade'. This is the simplified form; the traditional form is 國.

主 master (zhu³)

This character originally meant 'wick' or 'torch' but today means 'master', 'owner' or 'host'.

全 whole (quan²)

This character is a combination of 'to enter' 入 and 'king' (in this instance, actually 'jade'). It represents belongings under a roof. It also means 'full' or 'treasure'.

女王 queen (nu³ wang²)
woman + king

国王 king (guo² wang²)
country + king

王国 kingdom
(wang² guo²)
king + country

美国 USA (mei³ guo²)
beautiful + country

## 川 river (chuan[1])

The oracle-bone inscription of this character represented a river running between two shores. Today the character comprises three vertical lines, indicating a flowing river. It can also be used to refer to the province of Sichuan, known for its four rivers.

## 州 state (zhou[1])

Add three dots next to the three lines of 'river' to form the character for 'state'.

**舟 boat** (zhou¹)

This character depicts the shape of an ancient Chinese wooden vessel, which looks similar to a punt on a river.

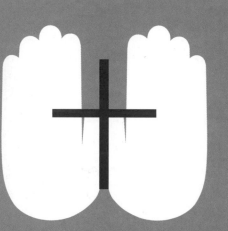

### 一 one (yi¹)

This is the first stroke taught to children. It means 'one'.

### 二 two (er⁴)

One stroke plus another is two.

### 三 three (san¹)

One plus two is three.

### 四 four (si⁴)

The number four is considered unlucky, because it sounds like 'death' 死 (si³).

### 五 five (wu³)

The etymology of this character is disputed, but it can also be used as a surname.

### 六 six (liu⁴)

The number six represents wealth in Cantonese, because it sounds like 'good fortune' 祿 (lu⁴).

七 seven (qi[1])

The number seven is considered a lucky number by people in relationships.

八 eight (ba[1])

The number eight is considered one of the luckiest numbers in Asia, because it sounds similar to the first character in 'prosper' 發財 (fa[1] cai[2]).

九 nine (jiu[3])

Nine once resembled the character for 'hand' 手 (see p. 100).

十 ten (shi[2])

The character for ten alludes to a complete unit. I like to imagine it as an 'X' marking the end of a unit of ten.

## 虫 bug (chong[2])

This character was based on the curled body of a poisonous snake; you can almost see the hood of a cobra in the character. It also means 'worm'. If you see this building block in a compound character, it tends to refer to some sort of insect, reptile or shellfish – for example, 'snake' 蛇, 'frog' 蛙 and 'clam' 蛤. Its traditional form is 蟲 (see p. 127).

## 長 tall/length
(chang[2])

The original form of this character depicted a person with very long hair, indicating 'being long' or the idea of length. The simplified form is 长.

## 賬 account/bill
(zhang[4])

This character comprises the building block for 'shell' (see p. 130), indicating the meaning, and 'length', indicating the pronunciation (see p. 11). Shells are associated with wealth, hence the meaning of the character. The simplified form is 账.

心 heart (xin[1])

This character originally
depicted a heart, but it
has since evolved to its
present form.

............................................

忄 heart/vertical
core (xin[1])

This character is the form
of 'heart' that is used as
a component in certain
compounds. It is known as
竖心旁, the 'vertical core'.
See 'fear' opposite for an
example of this character.

must

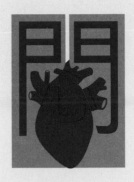

bored

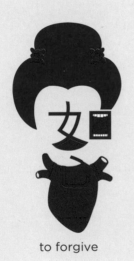

to forgive

帕

fear

必 must (bi⁴)

This character is a combination of 'heart' and a line ( 丿 ). The original form of the compound comprised 八 and 弋, indicating 'using wood as a marker'.

悶 bored (men¹)

This character comprises 'heart' inside 'door'. Imagine that it symbolizes a heart that wishes to leave because it is bored. The simplified form is 闷.

恕 to forgive (shu⁴)

This character is a combination of 'if' (see 'to obey', p. 48) and 'heart'. You must often ask yourself if your heart can forgive a wrong. It's a slightly scary image, however.

怕 fear (pa⁴)

This character is a combination of 'heart' and 'white'. When someone is scared or frightened, it is often said that they have gone white.

安心 contented (an¹ xin¹)
peaceful + heart
(see p. 93 for 'peaceful')

小心 be careful (xiao³ xin¹)
small + heart
(see p. 132 for 'small')

全心 whole-heartedly
(quan² xin¹)
whole + heart

## 刀 knife (dao¹)

The earliest form of this character, in oracle-bone inscriptions, was a sketch of two blades with two handles. However, the handles have not been included in any form since the clerical change. This character can now be used to refer to all items related to knives.

## 刂 knife (dao¹)

This character is the form of 'knife' that is used as a component in certain compounds. See 'to row' opposite for an example of this character.

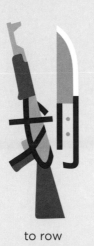

to row

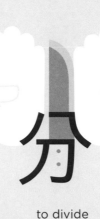

to divide

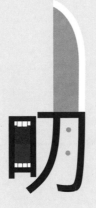

talkative

到 to illuminate

**划 to row** (hua²)

This character is a combination of 'weapon' (see p. 124) and 'knife'. As well as 'to row' (a boat), it can mean 'to pull' or 'to stroke'.

**分 to divide** (fen¹)

This character shows 'knife' under the number eight, and represents a knife cutting something in two.

**叨 talkative** (dao¹)

This character is a combination of 'mouth' and 'knife', indicating chatter or noise.

**照 to illuminate** (zhao⁴)

This character is a combination of 'knife', 'sun', 'mouth' and 'fire'. It means 'illuminate' or 'light up' when used as a verb, or 'bright' when used as an adjective.

**分心 to distract**
(fen¹ xin¹)
to divide + heart

**分明 clearly** (fen¹ ming²)
to divide + bright

**分子 molecule** (fen¹ zi³)
to divide + son
(see p. 96 for 'son')

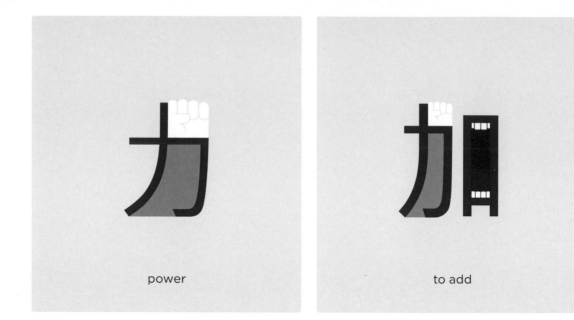

power

to add

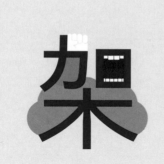

to construct

to drive

### 力 power (li⁴)

This character originally meant 'plough'. Ploughs require powerful animals to pull them. The meaning has been extended to refer to the power to pull the plough.

### 加州 California
(jia¹ zhou¹)
California + state

### 加 to add (jia¹)

This character is a combination of 'power' and 'mouth'. It also means 'increase'. This is also an abbreviation of California, USA (see below).

### 架 to construct (jia⁴)

This character is a combination of 'to add' and 'tree'. It means 'construct', 'build up' or 'stand' when used as a verb, and 'shed frame' when used as a noun.

### 駕 to drive (jia⁴)

This character is a combination of 'to add' and 'horse'. It also means 'to ride'. The simplified form is 驾.

## 豕 pig (shi[3])

The ancient character for 'pig', 'swine' or 'hog' featured a long snout, a big belly, hooves and a tail.

## 豬 pig (zhu[1])

This is the more commonly used character for 'pig'. You can still see the building-block character on the left-hand side of this compound.

⊓ roof (mian²)

The building block for
'roof' is hardly ever seen
independently of another
character. It is mostly used
as a component of many
characters relating to
habitation and architecture.

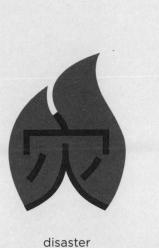

disaster

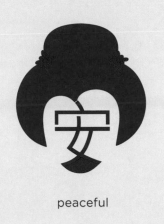

peaceful

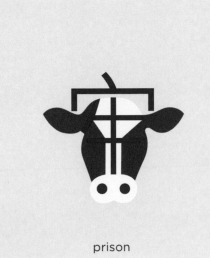

prison

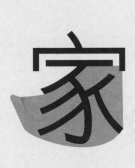

home

### 灾 disaster (zai¹)

This character is a combination of 'roof' and 'fire'. I think anyone with a burning roof would consider it a disaster! This is the simplified form; the traditional form is 災, a combination of 'river' and 'fire'.

**水灾** flood (shui³ zai¹)
water + disaster

### 安 peaceful (an¹)

This is a more positive compound featuring the building block for 'woman'. Remember that, traditionally, a peaceful home was one run by a woman.

**火灾** fire disaster (huo³ zai¹) fire + disaster

### 牢 prison (liao²)

Cows and buffalo were used as beasts of burden. The original meaning of this compound was 'pen', but it has since been extended to mean 'prison' when used as a noun.

**天灾** natural disaster (tian¹ zai¹) sky + disaster

### 家 home (jia¹)

In ancient China, pigs were raised indoors to keep them safe. Pigs in the house then became associated with a bountiful home. This character also means 'family'.

**大家** everybody (da⁴ jia¹) big + home

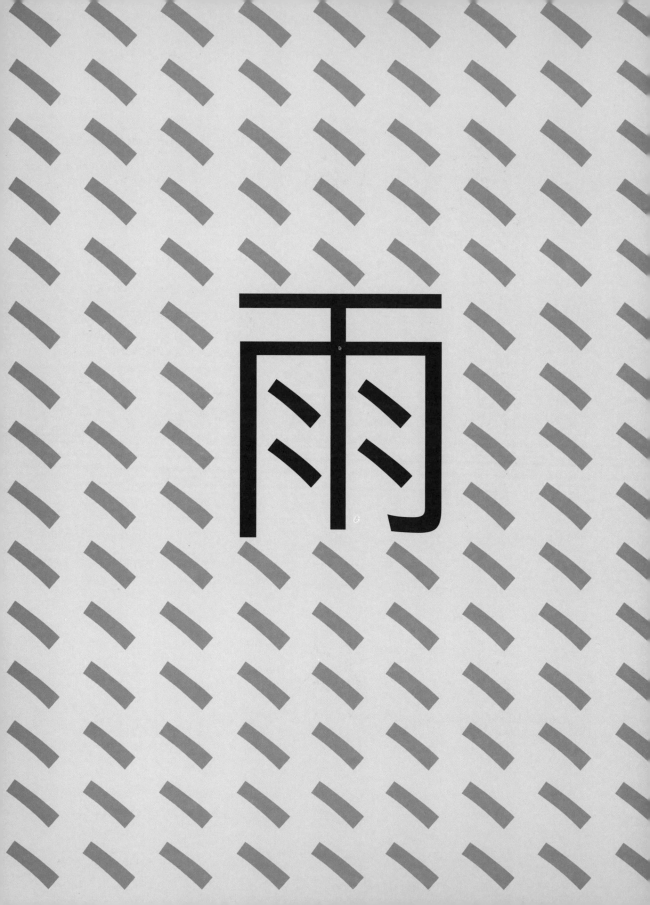

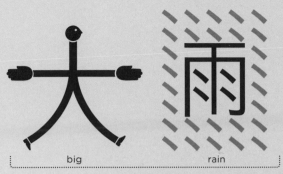

big    rain

**rain shower**

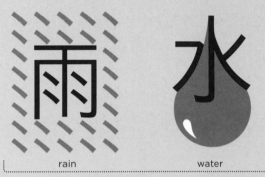

rain    water

**rainwater**

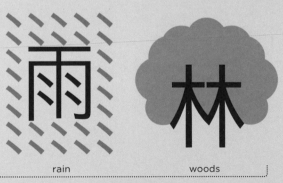

rain    woods

**rainforest**

## 雨 rain (yu³)

This character depicts water falling from the sky. The top horizontal line (一) represents the sky, while the figure ⊓ represents the space outside a city. As a whole, the character alludes to 'water scattered outside the city'.

## 大雨 rain shower (da⁴ yu³)

big + rain = [literally] big rain = rain shower

## 雨水 rainwater (yu³ shui³)

rain + water = rainwater

## 雨林 rainforest (yu³ lin²)

rain + woods = rainforest

子 son (zi³)

The earliest form of this character, in oracle-bone inscriptions, depicted a baby with a head, two arms and one leg, and meant 'baby' or 'infant'. The character has now been extended to mean 'son' or 'child'.

In addition to the 'son/child' meaning, 子 is often used as a suffix for single-syllable nouns or when referring to small objects. See, for example, the phrase 'day' opposite. In such instances, it is pronounced 'zi'.

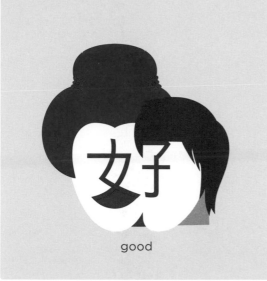

good

character

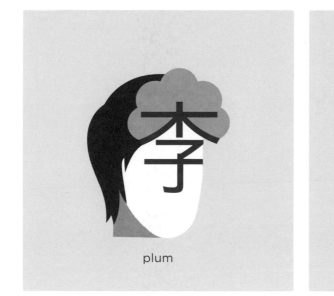

plum

twins

### 好 good (hao³)

This character is a combination of 'woman' and 'son'. In ancient China, the foremost requirement of a good woman was to bear a son in order to continue her husband's line. The character can also mean 'such'.

子女 offspring (zi³ nu³)
son/child + woman

### 字 character (zi⁴)

This compound is a combination of 'roof' and 'son'. When boys are born under a roof, it means a growth of population, which perpetuates civilization and literature. So this means 'character' (or 'word') in Chinese literature.

王子 prince (wang² zi³)
king + son

### 李 plum (li³)

This character is a combination of 'tree' and 'son'. Plums were considered a symbol of endurance in ancient China, as their flowers bloomed in winter. This is also a very common surname, translated as Li or Lee.

日子 day (ri⁴ zi)
sun/day + son

### 孖 twins (zi¹)

This character comprises two 'son' building blocks. Twins were considered a sign of either good luck or bad luck, depending on the region.

好心 good intention
(hao³ xin¹)
good + heart

# 目 eye (mu⁴)

Traditionally, in oracle-bone inscriptions, this character was eye-shaped, but its form was treated as straight lines in seal script.

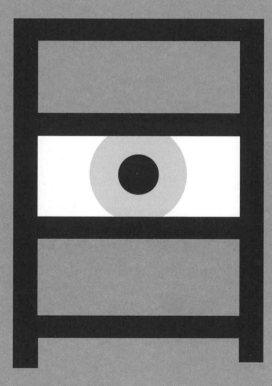

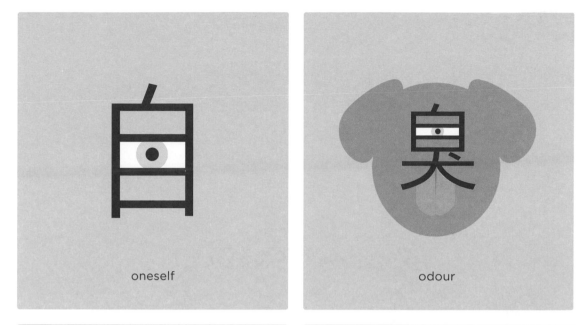

oneself

odour

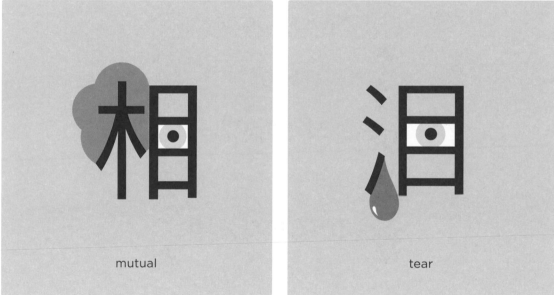

mutual

tear

**自 oneself (zi⁴)**

This character once meant 'nose', but it now means 'oneself', because people usually point to their face (specifically their nose) when they talk about themselves.

**臭 odour (chou⁴)**

This character is a combination of 'oneself' and 'dog'. It originally meant 'to smell', because a dog's nose is particularly sensitive. It has since evolved to mean 'odour'.

**相 mutual (xiang¹)**

This character is a combination of 'tree' and 'eye'. Its composition alludes to the idea of taking a close look or observing. It has now been extended to mean 'mutual' or 'image'.

**泪 tear (lei⁴)**

The traditional form of this character, 淚, is a combination of 'water' and 'perverse'. This simplified form is a combination of 'water' and 'eye'.

手 hand (shou³)

In oracle-bone inscriptions, the form of this character was an abstract depiction of five fingers with the lower part of the arm.

扌 hand (shou³)

This character is the form of 'hand' that is used as a component in certain compounds. It is known as 提手旁, the 'lifting hand'. See 'to assist' opposite for an example of this character.

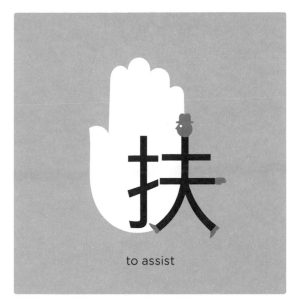

to assist

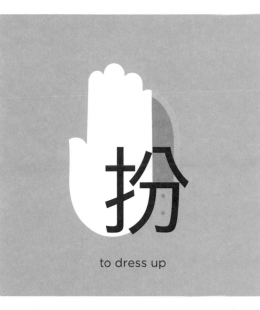

to dress up

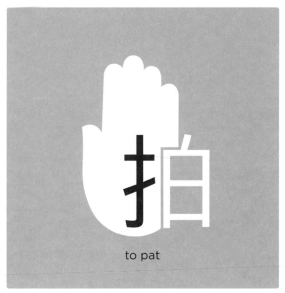

to pat

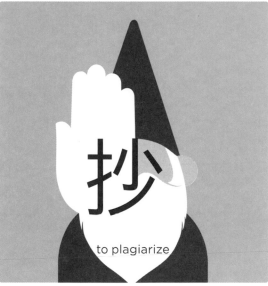

to plagiarize

### 扶 to assist (fu²)

This character's composition symbolizes a man being supported by a helping hand. It can also mean 'to support', 'to help', 'to protect' and 'to hold on'.

### 扮 to dress up (ban⁴)

This character is a combination of 'hand' and 'to divide'. The building block on the left indicates the meaning, while the compound on the right indicates pronunciation.

### 拍 to pat (pai¹)

This character is a combination of 'hand' and 'white'. 'Hand' indicates the meaning; 'white' indicates pronunciation.

### 抄 to plagiarize (chao¹)

This character is a combination of 'hand' and 'little' (see p. 133). It means 'to plagiarize' or 'to copy'.

扶手 handrail
(fu² shou³)
to assist + hand

人手 manpower
(ren² shou³)
person + hand

拍手 to clap hands
(pai¹ shou³)
to pat + hand

小抄 cheat sheet
(xiao³ chao¹)
small + to plagiarize
(see p. 132 for 'small')

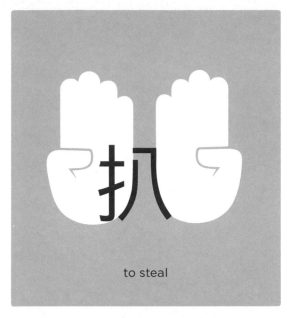

to steal

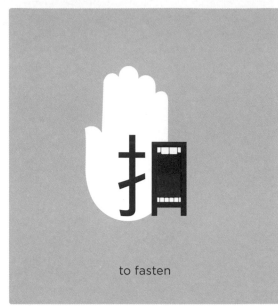

to fasten

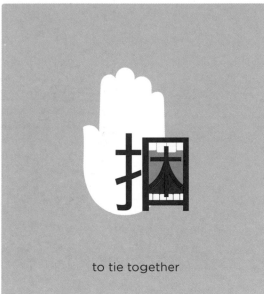

to tie together

to seek

扒 to steal (pa²)

This character is a combination of 'hand' and the number eight. It originally meant 'to dig out', 'to crawl' or 'to crouch', but has been extended to mean 'to steal'. Imagine a thief crouching by you and digging out your wallet.

扣 to fasten (kou⁴)

This character is a combination of 'hand' and 'mouth'. It has many different meanings, including the verbs 'rein', 'knock', 'strike', 'tap', 'button', 'buckle', 'deduct', 'detain', 'smash'. When used as a noun, it means 'button'.

捆 to tie together (kun³)

This character is a combination of 'hand' and 'enclosure' 困. To remember it, imagine a captive's hands tied together.

找 to seek (zhao³)

This character is a combination of 'hand' and 'weapon' (see p. 124), and indicates a hand taking up arms, perhaps to search for an escaped prisoner.

飞 to fly (fēi)

This character reminds me slightly of a hummingbird with its long beak. It can also mean 'dart' and 'to go quickly'. This is the simplified form; the traditional form is 飛.

# 戶 household (hu⁴)

This character represents a door with one panel. It can be used to refer to either a door or a window, but is most commonly used to mean 'household'. Its simplified form is 户.

........................................................

## 大戶 rich household
(da⁴ hu⁴)

big + household

## 貧戶 poor household
(pin² hu⁴)

poor + household
(see p. 131 for 'poor')

## 賬戶 bank account
(zhang² hu⁴)

account + household

## 网 net (wang³)

This is the simplified form of 'net'. The traditional form 網 did not come into being until the clerical change. The traditional form is a combination of 'silk' 糸 on the left, indicating the materials, and 'net/to deceive' 罔 on the right, representing the pronunciation and the meaning.

## ⺲ net (wang³)

This character is the form of 'net' that is used as a component in some compounds. Sometimes, owing to a person's handwriting, this character can look very similar to the number four 四. See 'to buy' on p. 131 for an example of this character.

夕 dusk (xī)

This character represents
the setting sun, and also
means 'evening' or 'sunset'.

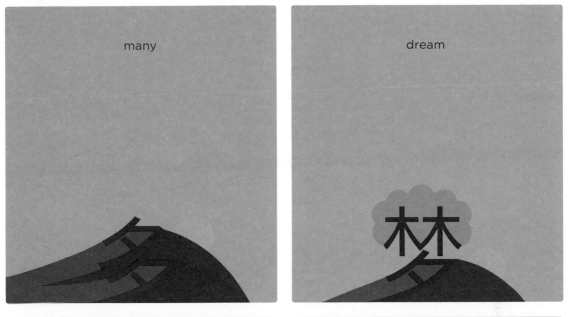

many

dream

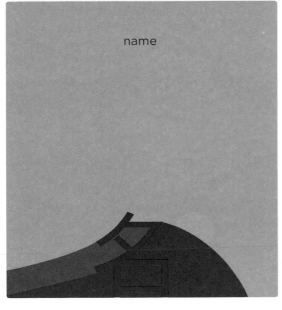

name

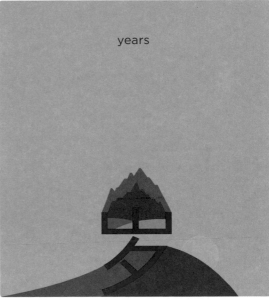

years

**多 many** (duo¹)

This character comprises two 'dusk' building blocks, suggesting the accumulation of time. Accumulation implies 'many'.

**多少 how much**
(duo¹ shao³) many + too little (see p. 133 for 'little')

**梦 dream** (meng⁴)

This character is a combination of 'woods' and 'dusk'. It is the simplified form; the traditional form 夢 is a combination of 'unclear' 苜, 'person' and 'dusk', and means 'unclear illusion'.

**名 name** (ming²)

This character is a combination of 'dusk' and 'mouth'. It alludes to parents calling their children's names as evening fell. The compound also means 'famous'.

**岁 years** (sui⁴)

This character is a combination of 'mountain' and 'dusk'. It is the simplified form; the traditional form is 歲. The most common usage of 歲 is to count a person's age; for example, 一歲 means 'one year old'.

言 to talk (yan[2])

In oracle-bone and bronze inscriptions, the form of this character was very similar to the character 舌, which means 'tongue'. The only difference was a short horizontal stroke added to the top of the character, indicating that the tongue was in use. This character also means 'speech' or 'to speak'.

訁 to talk (yan[2])

This character is the form of 'to talk' that is used as a component in certain simplified Chinese compounds.

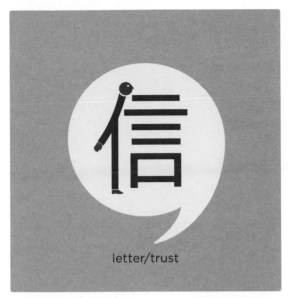

letter/trust

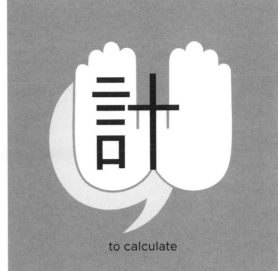

to calculate

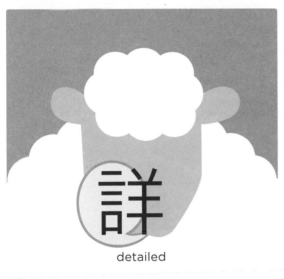

detailed

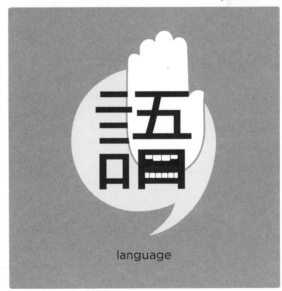

language

信 letter/trust (xin⁴)

This character, which is a combination of 'person' and 'to talk', originally referred to 'people's speech', but has been extended to mean 'letter' or 'trust'. Do you trust everything people tell you?

自信 self-confidence
(zi⁴ xin⁴)
oneself + trust

計 to calculate (ji⁴)

This character is a combination of 'to talk' and the number ten, and means 'to calculate' or 'to count'. If you can count to ten, then you can calculate basic maths. The simplified form is 计.

相信 to believe
(xiang¹ xin⁴)
mutual + trust

詳 detailed (xiang²)

This character is a combination of 'to talk' and 'sheep'. It means 'observe carefully' when used as a verb, 'detailed' or 'tiny' as an adjective, or 'details' or 'particulars' as a noun. The simplified form is 详.

日本語 Japanese
language (ri⁴ ben³ yu³)
Japan + language

語 language (yu³)

The character is a combination of 'to talk' and 'myself' 吾, which is a combination of the number five and 'mouth'. It means 'language' or 'words'. The simplified form is 语.

國語 official language
(guo² yu³)
country + language

Ⅲ dish (min³)

This character means
'dish' or 'shallow container'.
The earliest form of the
character looked like a
goblet or a vessel with
a stand. After the clerical
change, the goblet
disappeared from the
character. It refers to dishes,
cups and eating utensils.

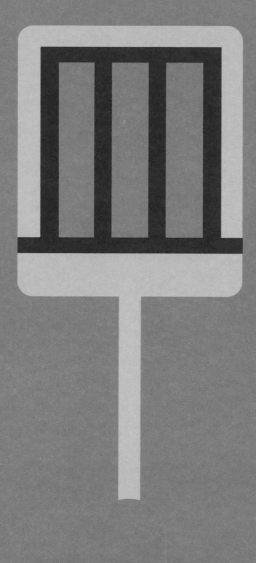

己 self (ji³)
The rope shape of this
character refers to 'self'.

自己 myself (zi⁴ ji³)
oneself + self

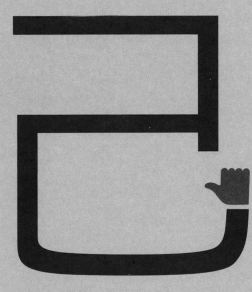

辶 walking (chuo⁴)

You won't see this building block appearing by itself. If you recognize this as a component of a character, you will know that the compound has something to do with 'walking'.

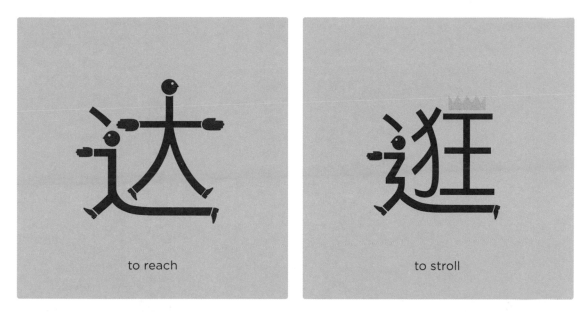

to reach

to stroll

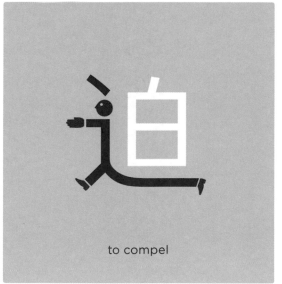

to compel

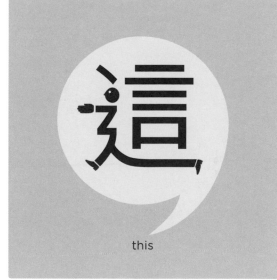

this

### 达 to reach (da²)

This is the simplified form of the character, and is a combination of 'walking' and 'big', indicating reaching a destination after a long walk. The traditional form is 這.

**达人** expert
(da² ren²)
to reach + person

### 逛 to stroll (guang⁴)

This character is a combination of 'walking' and 'crazy' 狂, which is a combination of 'dog' and 'king'. Some would think that strolling around with no destination in mind is a crazy waste of time. The simplified form is 逛.

**狂犬** mad dog
(guang⁴ quan³)
crazy + dog

### 迫 to compel (po⁴)

This is the simplified form of the character, and is a combination of 'walking' and 'white'. It also means 'to approach' or 'to force', and 'urgent' when used as an adjective. Its traditional form is 迫.

### 這 this (zhe⁴)

The traditional form of this character is a combination of 'walking' and 'to talk'. The simplified form 这 is a combination of 'walking' and 'literature' 文.

土 soil (tu³)

You can imagine the bottom stroke is the horizon, and the cross towards the top is either a plant or some man-made structure. To differentiate this character from 'soldier' 士 (see p. 116), just remember that the horizon must be longer than the cross. 土 is also Earth, one of the five basic elements. When someone uses 'soil' as an adjective, especially in modern writing, it implies something unsophisticated.

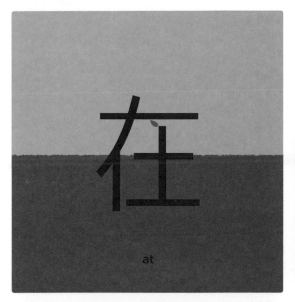

at

belly

to sit

fine

**在 at** (zai⁴)

This character is a combination of 'talent' 才 (cai²) and 'soil'. 'Talent' indicates the pronunciation; 'soil' indicates the meaning (see p. 11). Originally this character meant 'to exist', but it has been extended to mean 'at', 'in' or 'on'.

**自在 unrestrained**
(zi⁴ zai⁴)
oneself + at

**肚 belly** (du⁴)

This character is a combination of 'flesh' and 'soil'. The stomach is where the fruits of the soil are stored. This character has an alternative pinyin: du³.

**大肚子 pregnant**
(da⁴ du⁴ zi)
big + belly + son/child

**坐 to sit** (zuo⁴)

This character shows two people sitting on the soil.

**坐在 to sit at**
(zuo⁴ zai⁴)
to sit + at

**佳 fine** (jia¹)

This character is a combination of 'person' and what resembles two 'soil' building blocks. It also means 'good' or 'nice'.

**佳人 beautiful lady**
(jia¹ ren²)
fine + person

## 士 soldier (shi[4])

This character has many meanings, including 'soldier' and 'scholar'. It is a combination of the numbers one 一 and ten 十, indicating a man who can do all things well from beginning to end.

----

## 志 determination (zhi[4])

This character is a combination of 'soldier' and 'heart'. When a soldier or scholar sets his heart to something, he is determined - determined to win, to teach, to succeed.

## 士 scholar (shi⁴)

In ancient China, it was not unusual for military leaders to be scholars too, since Confucius taught that leaders should be both wise and decisive. This is reflected in the character's dual use.

## 吉 lucky (ji²)

This character is a combination of 'scholar' and 'mouth'. Scholars were highly respected in ancient China; they were members of the highest social hierarchy. When a scholar opened his mouth, his views were considered auspicious.

# 田 field (tian²)

This character depicts a piece of farmland on which criss-cross ditches have been dug for irrigation. It means 'field' or 'farm', and is also a building block for characters relating to farming and hunting.

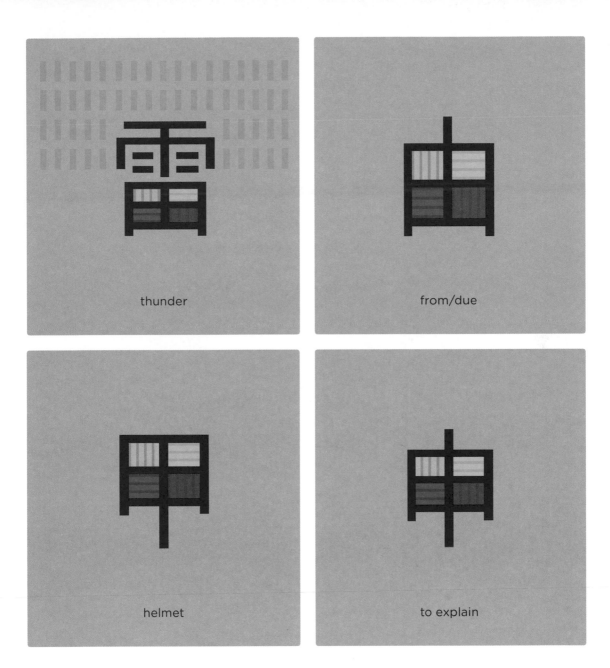

thunder

from/due

helmet

to explain

雷 **thunder** (lei[2])

This character is a combination of 'rain' and 'field'. In oracle-bone inscriptions, this character depicted thunder (represented by a circle and dots) and lightning.

由 **from/due** (you[2])

This is the character for 'field' with an extended upwards vertical stroke in the middle, indicating the road used to enter the farmland.

甲 **helmet** (jia[3])

Originally, this character depicted a cracked seed in a bud, and meant 'skin'. On account of its similar pronunciation to 'armour', it now also means 'helmet'.

申 **to explain** (shen[1])

In oracle-bone inscriptions, this character looked like lightning in the rain, and meant 'lightning'.

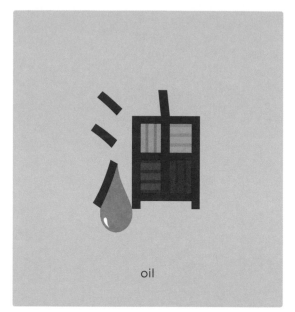

oil

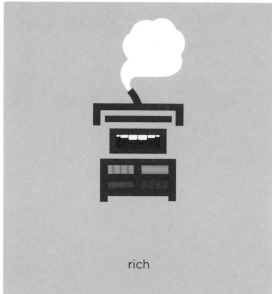

rich

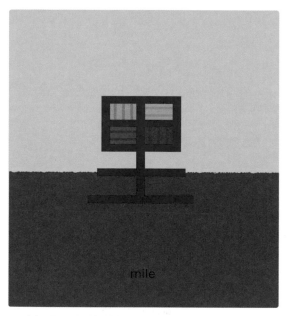

mile

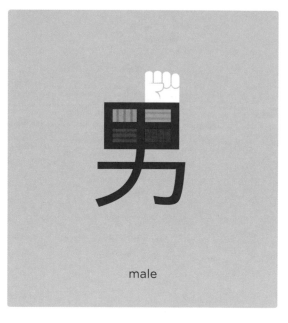

male

油 oil (you²)

This character is a combination of 'water' and 'field', and alludes to the liquid made from minerals under the fields, oil.

富 rich (fu⁴)

This character is a combination of 'roof', the number one, 'mouth' and 'field', and alludes to a wealthy family living in a comfortable home full of possessions.

里 mile (li³)

This character is a combination of 'field' and 'soil', and means 'village'. Over time its meaning has been extended to refer to the stretch of ground that a village occupies.

男 male (nan²)

This character is a combination of 'field' and 'power'. In ancient times men worked the fields. The character now refers to the masculinity associated with manual labour.

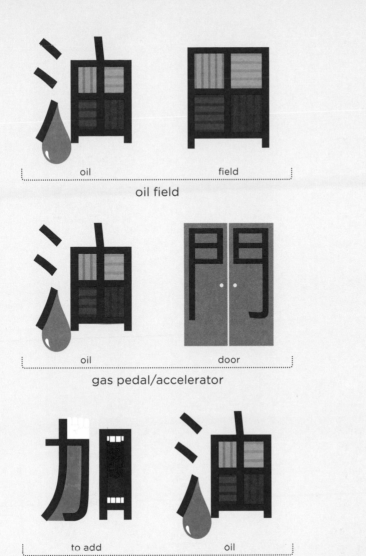

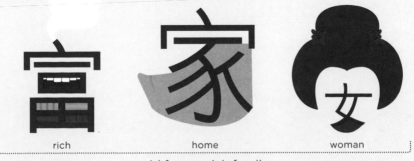

油田 oil field
(you² tian²)

oil + field = oil field

油門 gas pedal/
accelerator
(you² men²)

oil + door = [literally]
oil door = gas pedal

加油 to refuel
(jia¹ you²)

This phrase also means
'go on!' when used to cheer
someone to victory.
to add + oil = [literally]
to add oil = to refuel

富家女 girl from
a rich family
(fu⁴ jia¹ nu³)

rich + home + woman =
girl from a rich family

## 弓 bow (gong[1])

This character originally looked like a bow, but has since evolved into its current form, which looks similar to a bow missing its string.

........................................................

## 弱 weak (ruo[4])

This character is a combination of two 'bow' and two 'ice' (see p. 146) building blocks, and means 'weak' or 'brittle'.

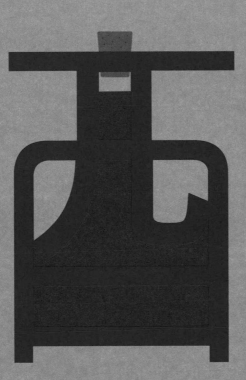

酉 wine vessel (you³)

This character originally took the shape of a jar, and meant 'wine'. It has since evolved to mean 'wine vessel'. This building block is also used in characters relating to the fermentation of wine or food.

.........................................

酒 wine (jiu³)

This character is a combination of 'water' and 'wine vessel'. If you prefer white wine at a restaurant, be sure to ask for 白酒.

## 戈 weapon (ge¹)

This character depicts a type of weapon similar to a dagger-axe, with a horizontal blade at its head and a long handle.

........................................................

## 我 me/I (wo³)

This character is a combination of 'hand' and 'weapon', and means 'me' or 'I'. It's one of the most useful compounds of 'weapon'.

**鹿 deer (lu⁴)**
In oracle-bone inscriptions, this character depicted deer's antlers, with its four legs below them.

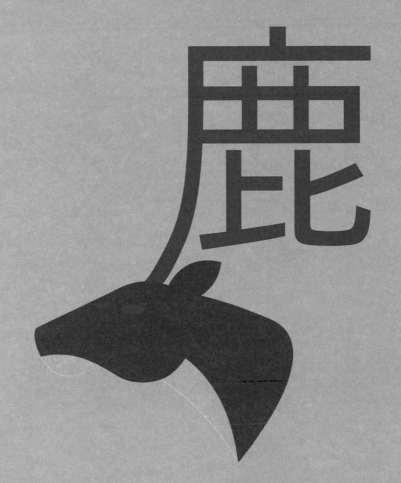

**犇 to flee** (ben[1])

Three cows together means 'to flee' or 'to run fast'. Imagine a herd of cows fleeing a predator. The simplified form of this character is 奔.

**猋 whirlwind** (biao[1])

Three dogs together means 'whirlwind'. Imagine a pack of dogs running around your legs.

**麤 rough** (cu[1])

Three deers together means 'rough', 'coarse' or 'big'.

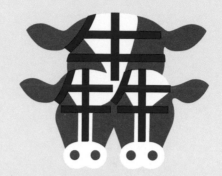

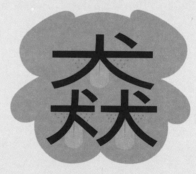

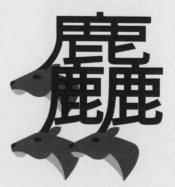

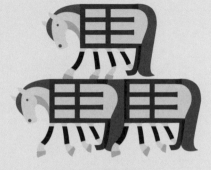

### 羴 rank odour (shan[1])

Three sheep or goats together indicates 'rank odour of sheep or goats'. A group of farm animals is never going to smell good.

### 驫 horses running (biao[1])

Three horses together means 'horses running'.

### 蟲 bugs (chong[2])

This is the traditional form of 'worms' or 'bugs', comprising three 'bug' building blocks. It is the more commonly used form of 'bug' 虫 in traditional Chinese. This character also means 'insects'.

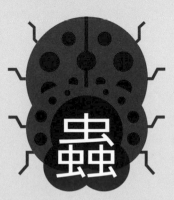

## ⺊ grass (cao³)

As in the case of the 'walking' building block, this form of 'grass' never appears by itself; it is only ever seen as part of a compound. When you see it, you know that the character refers to a type of flora or fauna. This character, along with 草 opposite, also means 'grass'.

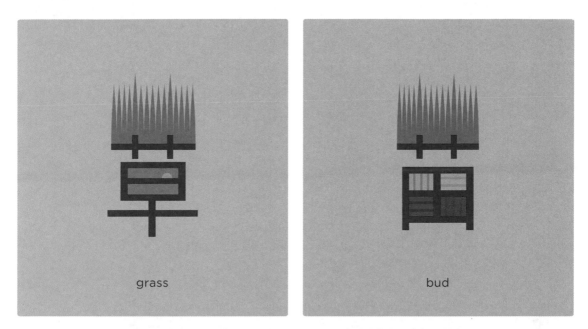

grass

bud

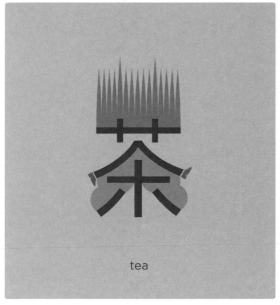

tea

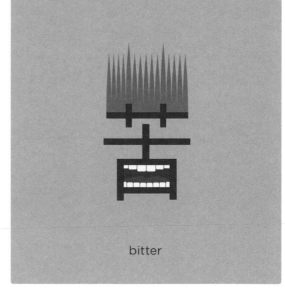

bitter

**草** grass (cao³)

This character is a combination of 'grass' and 'early' 早, and means 'grass' or 'herbs'.

**苗** bud (miao²)

This character is a combination of 'grass' and 'field', and refers to the buds that sprout in fields.

**茶** tea (cha²)

This character is a combination of 'grass', a component that resembles 'person' and 'tree', and can be translated as 'tea tree'. The original form of this character, 荼, meant 'bitter herb'.

**苦** bitter (ku³)

This character is a combination of 'grass' and 'old' 古. An old plant is not going to taste very good! This character also means 'illness'.

**貝** shell (bei[4])

In oracle-bone and seal scripts, this character originally depicted an open shell. In ancient China, shells were often used as money as well as for decoration. Therefore, the character also means 'money' or 'currency'. The simplified form is 贝.

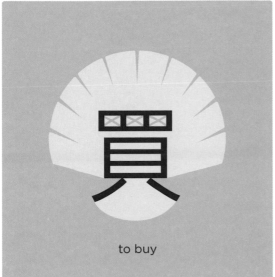

to buy

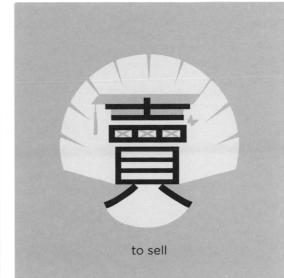

to sell

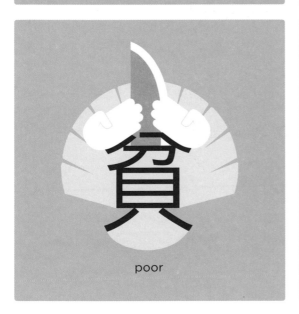

poor

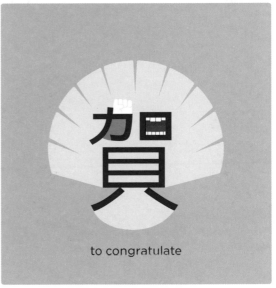

to congratulate

### 買 to buy (mai³)

This character is a combination of 'net' and 'shell'. It alluded to using a net to collect shells, which you could use to buy things. The simplified form is 买.

### 賣 to sell (mai⁴)

This character is a combination of 'scholar', 'net' and 'shell'. Originally it was a combination of 'to get out' and 'to buy', alluding to getting rid of purchases by selling them. The simplified form is 卖.

### 貧 poor (pin²)

This character is a combination of 'to divide' and 'shell'. As shells were once currency, dividing them would make you poorer. The simplified form is 贫.

### 賀 to congratulate (he⁴)

This character is a combination of 'to add' and 'shell'. Congratulations in China are often given in the form of money. The simplified form is 贺.

### 買賣 commerce
(mai³ mai⁴)
to buy + to sell

### 買主 customer
(mai³ zhu³)
to buy + master

### 買回 to buy back
(mai³ hui²)
to buy + to return

### 買家 buyer
(mai³ jia¹)
to buy + home

小 small (xiao³)

While the character
'big' 大 depicts a man
stretching his arms out
wide, indicating his large
size, 'small' originally
depicted a man kneeling
with his arms by his side to
appear small.

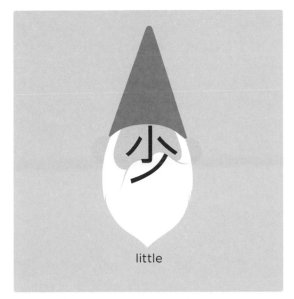

little

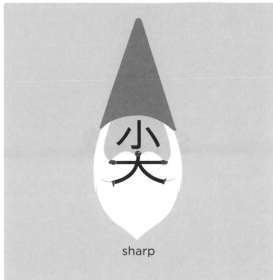

sharp

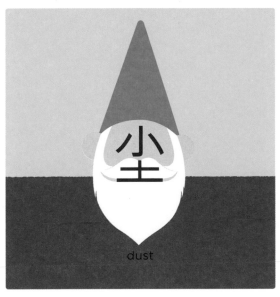

dust

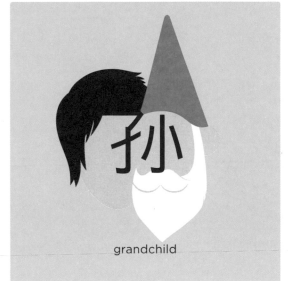

grandchild

### 少 little (shao³)

This character originally meant 'little', 'minus', 'few' or 'less', but has been extended to also mean 'young'. It has an alternative pinyin: shao⁴.

### 尖 sharp (jian¹)

This character is a combination of 'small' and 'big', and means 'sharp', 'pointed' or 'acute'. Imagine a triangle that is big or wide at its base then tapers to a small, sharp point.

### 尘 dust (chen²)

This character is a combination of 'small' and 'soil'. This is the simplified form; the traditional form is 塵, a combination of 'deer' and 'soil'. It alludes to the dust kicked up when a herd of deer run.

### 孙 grandchild (sun¹)

This character indicates a little child. This is the simplified form; the traditional form is 孫, a combination of 'child' and 'system' 系, indicating the continuation of children.

**小人** villain (xiao³ ren²)
small + person

**大小** size (da⁴ xiao³)
big + small

**孙女** granddaughter (sun¹ nu³)
grandchild + woman

**孙子** grandson (sun¹ zi)
grandchild + son

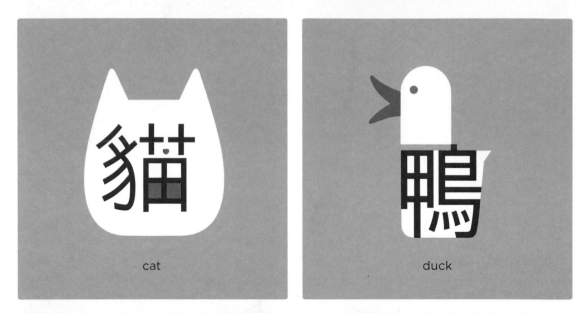

cat

duck

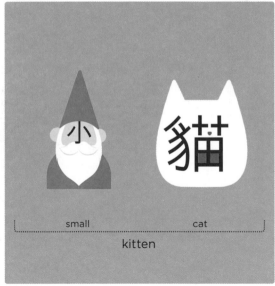

small · cat

kitten

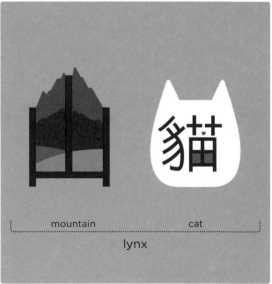

mountain · cat

lynx

**貓 cat** (mao¹)

This character is a combination of 'raccoon' 貍 and 'bud'. Its simplified form is 猫, which is a combination of 'dog' and 'bud'.

**鴨 duck** (ya¹)

This character is a combination of 'helmet' and 'bird'. A male mallard looks like it is wearing a green helmet. The simplified form of this character is 鸭.

**小貓 kitten** (xiao³ mao¹)

A very simple phrase; a small cat is a kitten. small + cat = kitten

**山貓 lynx** (shan¹ mao¹)

A lynx is a species of wildcat recognizable by its tufted ears. Lynx are normally found in high-altitude forests. mountain + cat = lynx

**貓王 Elvis Presley** (mao¹ wang²)

cat + king

**鬼** ghost (gui[5])

The original form of this character depicted a person with a terrible evil face. This building block is used in characters that relate to superstitions.

---

**小鬼** imp (xiao[3] gui[3])

little + ghost

# 勹 to wrap up (bao[1])

This building block means 'to wrap up'. Its most common form is 包.

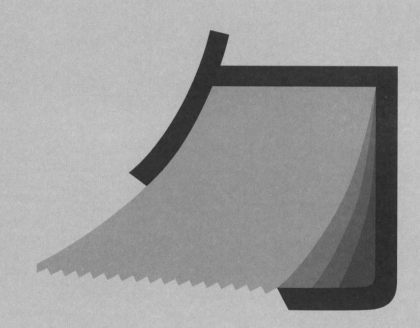

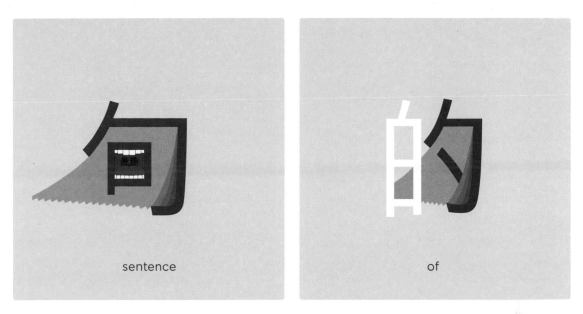

sentence

of

well distributed

even

句 sentence (ju⁴)

In oracle-bone inscriptions, this character was a combination of 'rope' 丩 and 'mouth'. Unlike 句子 (below), which usually refers to a specific sentence, this character tends to be used when counting (e.g. 'there are 10 sentences').

句子 sentence (ju⁴ zi)
sentence + son

的 of (de)

This character is a combination of 'white' and 'to wrap up'. It means 'of' and is one of the most frequently used Chinese characters.

好的 yes (hao³ de)
good + of

勻 well distributed (yun²)

This character can also mean 'to divide'. The combination of 'to wrap up' and the number two alludes to treating two things equally.

均勻 to distribute evenly (jun¹ yun²)
even + well distributed

均 even (jun¹)

This character is a combination of 'soil' and 'well distributed/to divide'. It alludes to an even division of land.

几 how many (ji³)

This is the simplified form of 'how many'; the traditional form is 幾, a combination of 'few' 幺 and 'defence' 戍, and originally meant 'fine' or 'slight'. This character has a number of alternative pinyins and meanings:
as noun = bench (ji¹)
as adverb = almost (ji¹)
as verb = reach/attain (ji¹)
as pronoun = several (ji³)

--------

机 machine (ji¹)

This character is a combination of 'tree' and 'how many'. Its traditional form is 機.

ordinary

quantity of flowers

male phoenix

female phoenix

凡 ordinary (fan²)

In oracle-bone and bronze scripts, this character represented building apparatus. It originally meant 'mould for making objects', and then evolved to mean 'ordinary'.

几天 several days
(ji³ tian¹)
how many + sky/day

朵 quantity of flowers (duo³)

This character is a combination of 'how many' and 'tree'. It refers to a unit, such as a dozen flowers. 几朵花? means 'how many flowers?' (ji³ duo³ hua).

几天? how many days?
(ji³ tian¹)
how many + sky/day

鳳 male phoenix (feng⁴)

This character is a combination of 'how many' and 'bird'. In Chinese mythology, the phoenix is the king of birds and symbolizes good fortune. The simplified form is 凤.

好几 several
(hao³ ji³)
good + how many/several

凰 female phoenix (huang²)

This character is a combination of 'how many', 'white' and 'king', and refers to the female phoenix of Chinese mythology.

十几 a dozen or so
(shi² ji¹)
ten + how many/almost

厶 private (si[1])

This character has looked
rather abstract throughout
its thousand years of
evolution, so I think this
illustration expresses
its meaning well. The
character has an alternative
pinyin: mou[3].

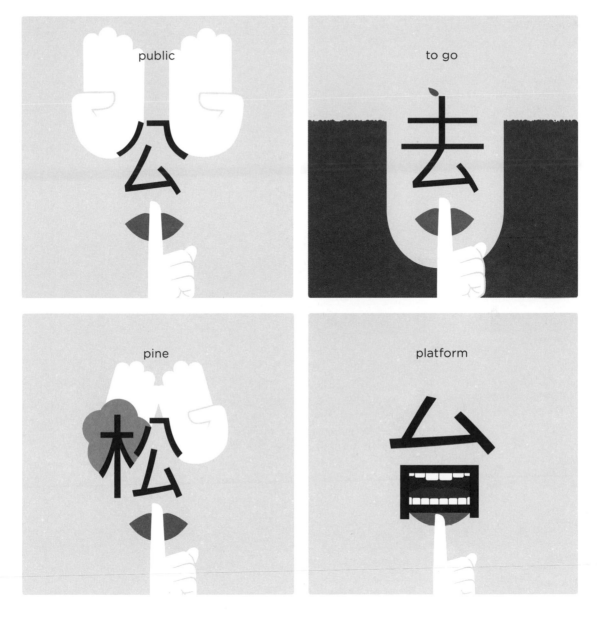

**公 public** (gong[1])

This character is a combination of the number eight and 'private'. It also means 'grandfather' when written 公公, or 'male' when referring to animals.

**去 to go** (qu[4])

This character is a combination of 'private' and 'soil'. It alludes to a person leaving a place to go somewhere.

**松 pine** (song[1])

This character is a combination of 'tree' and 'public'. A different character with the same pronunciation 鬆 can mean 'to relax' and 'loose'.

**台 platform** (tai[2])

This character is a combination of 'private' and 'mouth'. Normally an orator is the sole person to stand on a platform and deliver their speech. The other traditional form of this character is 臺.

**公安 police (China)**
(gong[1] an[1])
public + peaceful

**警察 police (Taiwan)**
(jing[3] cha[2])
police + to observe

**公主 princess**
(gong[1] zhu[3])
public + master

## 示 to reveal (shi[4])

This character originally meant 'stone table for sacrificial offerings'. In ancient times, sacrificial ceremonies were intended to demonstrate devotion to the gods. Therefore, the character 示 means 'to reveal' or 'to show'.

.................................................

## 礻 to reveal (shi[4])

This character is the form of 'to reveal' that is used as a component in certain compounds. See 'auspicious' opposite for an example of this character.

auspicious

society

god

blessing

**祥 auspicious**
(xiang²)

This character is a combination of 'to reveal' and 'sheep', and also means 'omen', 'good luck' and 'happiness'. People once sacrificed sheep for luck.

**社 society** (she⁴)

This character is a combination of 'to reveal' and 'soil', and originally referred to a place of worship. It has since evolved to mean 'society' or 'company'.

**神 god** (shen²)

This character is a combination of 'to reveal' and 'to explain'. God is omnipotent and omniscient. He reveals secrets.

**福 blessing** (fu²)

This character is a combination of 'to reveal' the number one, 'mouth' and 'field', and also means 'good fortune' or 'blessing'. It is commonly written on red paper during Chinese New Year.

**神社** shrine
(shen² she⁴)
god + society

**安祥** serene
(an¹ xiang²)
peaceful + auspicious

# 干 shield (gan[1])

The simplified form of this character is formed by the building blocks for the numbers one 一 and ten 十; the traditional form is 幹. In oracle-bone inscriptions, this character took the form of a fork-shaped weapon, used for both attack and defence. Today the character tends to mean 'to offend' or 'to intervene', but in its simplified form can also mean 'dry' or 'to do'.

sweat

flat

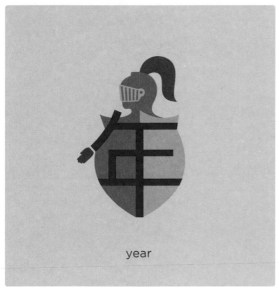

year

fate

汗 sweat (han⁴)

This character is a combination of 'water' and 'shield/dry', and alludes to a person being dry because they have sweated out all their water.

平 flat (ping²)

This character is a combination of 'shield' and the number eight. It also means 'gentle', 'equal' or 'level'.

年 year (nian²)

This character refers to the time required for the earth to orbit the sun once, based on the Chinese calendar. For example, the phrase 一年 means 'one year'. The character can also mean 'new year' or 'annual'.

幸 fate (xing⁴)

This character is a combination of 'shield' 干, 'soil' 土 and 'to be' ヽヽ. Ironically, this character originally meant 'torture'. Today it means 'fate' or 'good fortune'.

平安 safe
(ping² an¹)
flat/gentle + peaceful

幸福 happiness
(xing⁴ fu²)
fate + blessing

# 冫 ice (bing[1])

This character rarely appears by itself. Instead, it is used as part of a compound. It is commonly called 兩點水, 'two dots of water'.

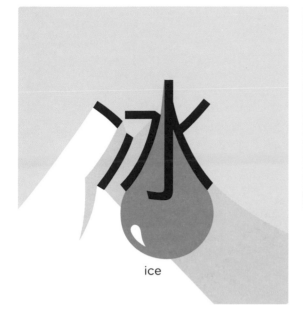

ice

frozen

winter

to gallop

### 冰 ice (bing[1])

This character is a combination of the building blocks 'ice' and 'water', indicating frozen water. 冰水 means 'iced water'.

### 凍 frozen (dong[4])

This character is a combination of 'ice' and 'east'. The coast of China lies to the east, and in winter icebergs would have come from the east. The simplified form is 冻.

### 冬 winter (dong[1])

This character is a combination of 'slow' 夂 ('slow' looks similar to the character for 'dusk', but has an extended stroke) and 'ice'. It translates literally as 'slow ice', which alludes to ice building up slowly over winter.

### 馮 to gallop (feng[2])

This character is a combination of 'ice' and 'horse', and means 'to gallop'. This character is also a surname. The simplified form is 冯.

# 欠 to owe (qian[4])

The earliest form of this character in oracle-bone inscriptions depicted a person kneeling with a wide-open mouth.
It is believed that this represented a person in the act of yawning, because the meaning of the character was 'to yawn'.

Since the clerical change, the wide-open mouth is no longer discernible in this character. However, characters with 欠 as a component are often related to opening the mouth and exhaling. When one yawns, it means one is tired and short of energy. Therefore, an extended meaning of 欠 is 'to lack', which is commonly used in modern Chinese.

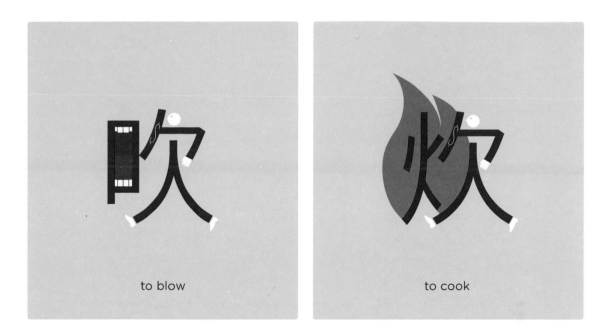

to blow

to cook

sequence

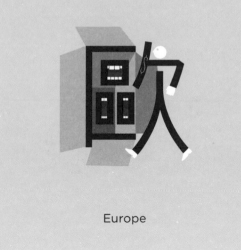

Europe

**吹 to blow** (chui¹)

This character is a combination of 'mouth' and 'to owe'. In this case, 'to owe' means 'to yawn'.

**炊 to cook** (chui¹)

This character is a combination of 'fire' and 'to owe'. in this case, 'to owe' means 'to blow', and refers to blowing the embers to cook your food.

**次 sequence** (ci⁴)

This character is a combination of 'ice' and 'to owe'. It is used to refer to the number of times that something happens. For example, the phrase 二次 means 'twice'.

**歐 Europe** (ou¹)

This character is a combination of 'area' 區 and 'to owe'. This character's pronunciation sounds similar to the English pronunciation of 'Europe'. The simplified form is 欧.

匕 **dagger** (bi³)

This character resembles the handle, or hilt, of a dagger or sword.

---

它 **it** (ta¹)

This character is a combination of 'roof' and 'dagger', and means 'it'.

to compare

to transform

finger

flower

### 比 to compare (bi³)

This character comprises two 'dagger' building blocks, and symbolizes two people walking in unison, shoulder to shoulder. It now means 'to compare'.

### 化 to transform (hua⁴)

This character is a combination of 'person' and 'dagger'. It is often seen in words relating to chemistry, especially when referring to elements and substances. It also means 'to melt' or 'to convert'.

### 指 finger (zhi³)

This character is a combination of 'hand' and 'purpose' 旨, which is a combination of 'dagger' and 'sun'. Fingers are what make your hands useful. The character also means 'point' when used as a verb.

### 花 flower (hua¹)

The character is a combination of 'grass' and 'to transform'. Flowers might look a bit like transformed grass.

# Advanced Sentences

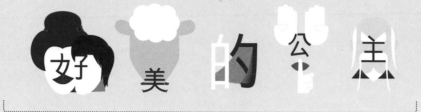

Such a beautiful princess
好美的公主 (pages 97, 41, 137, 141)

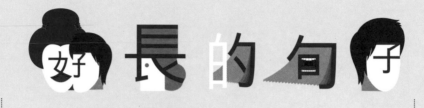

Such a long sentence
好長的句子 (pages 97, 85, 137)

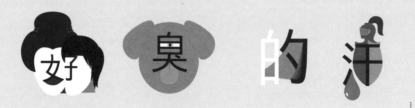

Sweat stinks
好臭的汗 (pages 97, 99, 137, 145)

The instruction from God
神的指示 (pages 143, 137, 151, 142)

Blessed woman from Shandong Province
幸福的山東女人 (pages 145, 143, 137, 54)

Everybody be careful
大家小心 (pages 93, 87)

Beautiful teenage girl
美少女 (pages 41, 133, 46)

The fish is so fresh
魚好鮮 (pages 25, 97, 41)

Ice-cold lady
冰山美人 (pages 147, 42, 41, 16)

The lamb is going home
小羊回家 (pages 132, 40, 23, 93)

Everyone is safe
人人平安 (pages 21, 145)

It rains too much
雨水太多 (pages 95, 19, 107)

Little prince
小王子 (pages 132, 97)

Grandson is growing up
孫子長大 (traditional Chinese); 孙子长大 (simplified Chinese)
(pages 133, 85, 17)

Woman with plastic surgery
人工美女 (pages 61, 41, 46)

Very kind Mrs Lee
大好人李太太 (pages 17, 97, 16, 19)

The younger sister is going to Japan
妹妹去日本 (pages 48, 141, 55)

How much does this flower cost?
這朵花賣多少? (pages 113, 139, 151, 131, 107, 133)

Grandfather returned from the forest
公公從森林回來 (traditional Chinese); 公公从森林回来 (simplified Chinese)
(pages 141, 17, 33, 37)

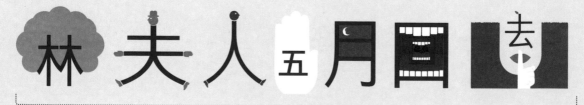

Madam Lin is returning in May
林夫人五月回去 (pages 33, 18, 82, 56, 23, 141)

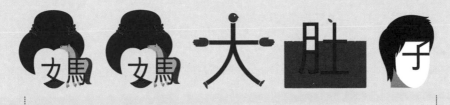

Mama is pregnant
媽媽大肚子 (pages 77, 115)

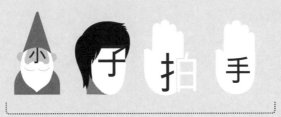

The brat is clapping his hands
小子拍手 (pages 132, 96, 101)

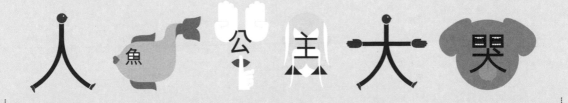

The mermaid princess burst into tears
人魚公主大哭 (pages 24, 141, 27)

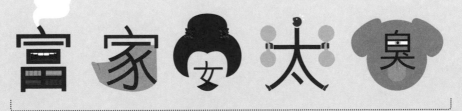

The rich girl stinks
富家女太臭 (pages 121, 19, 99)

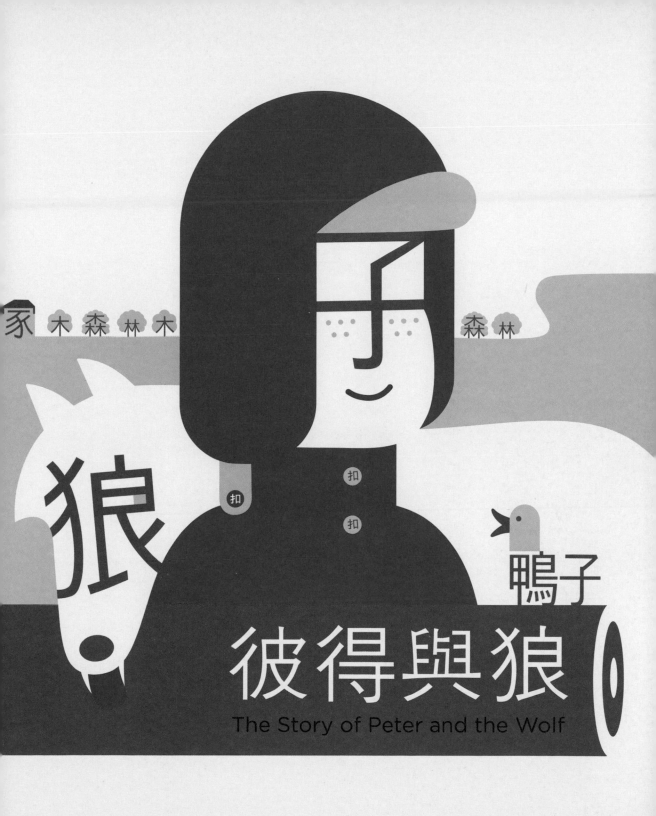

# 彼得與狼

The Story of Peter and the Wolf

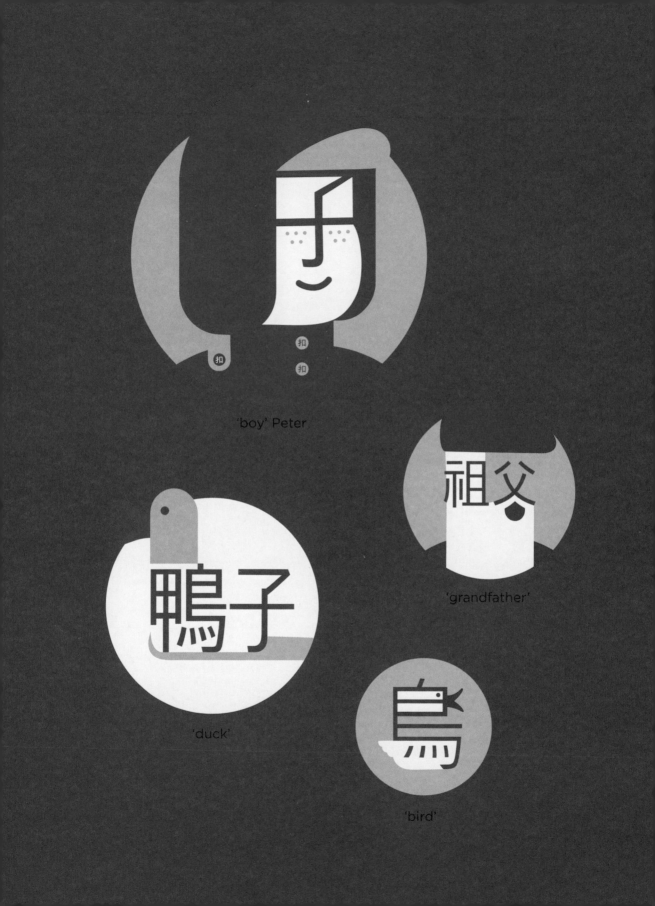

'boy' Peter

'grandfather'

'duck'

'bird'

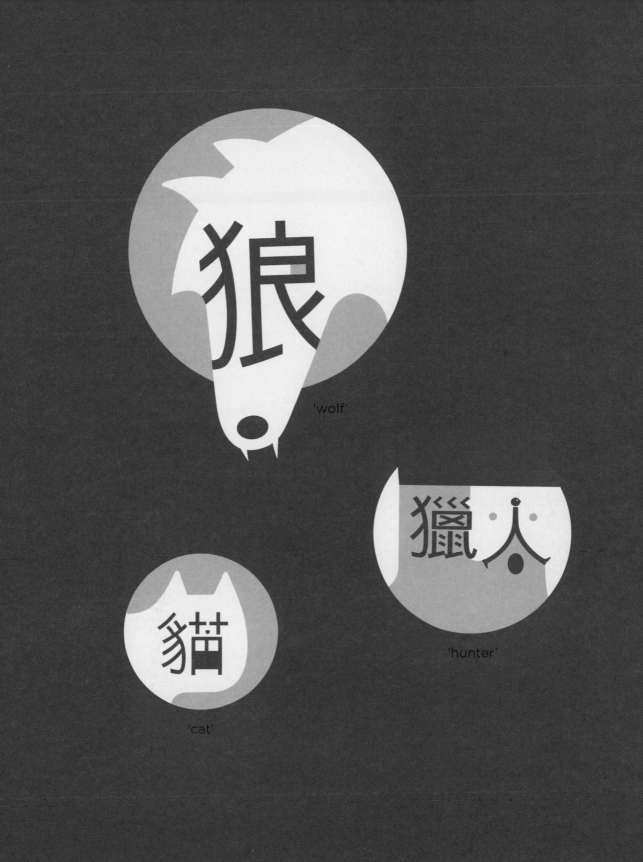

'wolf'

'hunter'

'cat'

Once upon a time, on the edge of a forest clearing, there lived a boy named Peter. Early one morning, Peter left his home to go for a walk in the dark forest, leaving the gate to his house open.

家 木森林木森林木森林

A nearby duck, noticing that the gate was open, decided to go for a quick swim in Peter's yard.

While the duck was swimming, a bird flew down beside it and mocked, 'What kind of bird are you, if you can't fly?' To which the duck indignantly replied, 'What kind of bird are you, if you can't swim?'

架 ➤ 鴨子

While the duck and the bird were arguing, a sly cat crept slowly towards them. The cat thought to itself, 'I will catch that little bird while it's arguing with the duck!' But, before the cat could pounce, Peter warned the bird, who flew to safety.

貓

喵喵

鳥 吱吱

木

呱呱 鴨子

Hearing Peter's call, his grandfather, who hadn't realized that Peter had left the safety of the house, scolded him: 'Suppose a wolf came out of the forest!' he chided.

Peter scoffed, 'Boys like me are not afraid of wolves!' But at that very moment, unbeknown to them, a big, hungry grey wolf was stalking through the forest straight towards them.

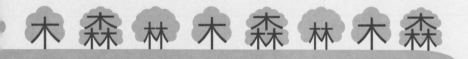

呱呱

鴨子

When Peter had returned to the safety of his home, the hungry wolf slunk out of the forest. In a flash, the bird flew up into the tallest tree, but the duck, who could not fly, was no match for the speed of the wolf. With one huge gulp, the wolf caught the duck and swallowed it whole!

Seeing that his friends were in trouble,
Peter fetched a rope and climbed into
a nearby tree. As the bird distracted the
animal, Peter lowered a noose and caught
the wolf by its tail.

呱呱

狼

獵人

扣

While the wolf struggled, the noose
became tighter and tighter until, at last,
the wolf could struggle no more. A nearby
hunter, who had been trying to track the
wolf, spied Peter in the tree and offered to
shoot the wolf, but Peter had another idea.

With the wolf safely tied up, Peter led the hunter to a zoo in a nearby village, where the wolf stayed for the rest of its days.

扣

扣

扣

三 three (san¹)
One plus two is three.

# REFERENCE

Building Block Plates
Index of Characters and Phrases

# Building Block Plates

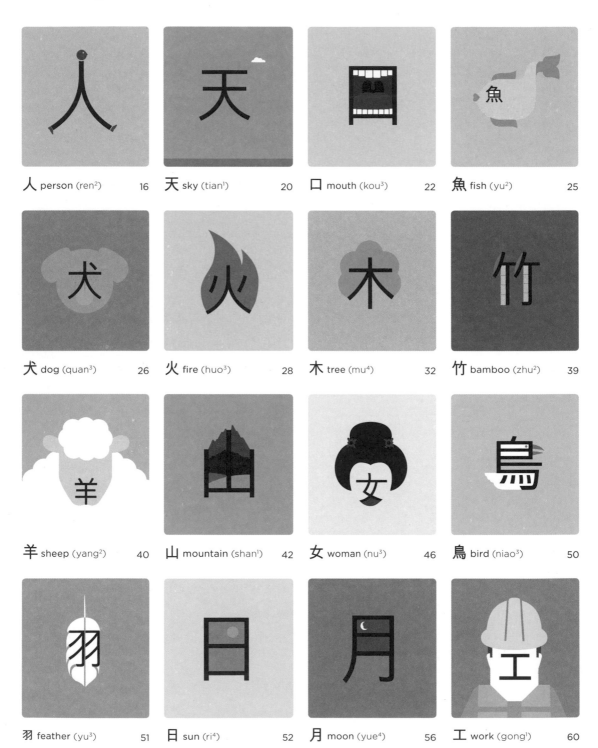

人 person (ren[2])  16

天 sky (tian[1])  20

口 mouth (kou[3])  22

魚 fish (yu[2])  25

犬 dog (quan[3])  26

火 fire (huo[3])  28

木 tree (mu[4])  32

竹 bamboo (zhu[2])  39

羊 sheep (yang[2])  40

山 mountain (shan[1])  42

女 woman (nu[3])  46

鳥 bird (niao[3])  50

羽 feather (yu[3])  51

日 sun (ri[4])  52

月 moon (yue[4])  56

工 work (gong[1])  60

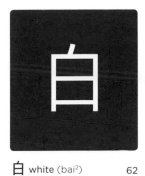

白 white (bai²)     62

虎 tiger (hu³)     64

門 door (men²)     66

水 water (shui³)     70

牛 cow (niu²)     74

馬 horse (ma³)     76

玉 jade (yu⁴)     78

川 river (chuan¹)     80

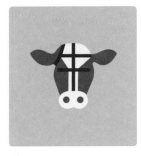

舟 boat (zhou¹)     81

一 one (yi¹)     82–83

虫 bug (chong²)     84

長 tall/length (chang²) 85

心 heart (xin¹)     86

刀 knife (dao¹)     88

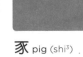

豕 pig (shi³)     91

宀 roof (mian²)     92

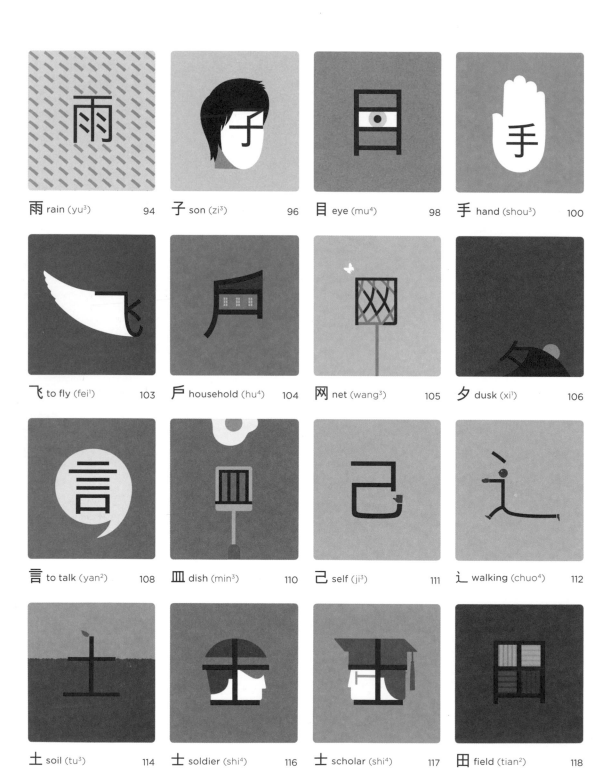

雨 rain (yu$^3$)    94

子 son (zi$^3$)    96

目 eye (mu$^4$)    98

手 hand (shou$^3$)    100

飞 to fly (fei$^1$)    103

戶 household (hu$^4$)    104

网 net (wang$^3$)    105

夕 dusk (xi$^1$)    106

言 to talk (yan$^2$)    108

皿 dish (min$^3$)    110

己 self (ji$^3$)    111

辶 walking (chuo$^4$)    112

土 soil (tu$^3$)    114

士 soldier (shi$^4$)    116

士 scholar (shi$^4$)    117

田 field (tian$^2$)    118

弓 bow (gong¹)    122

酉 wine vessel (you³)    123

戈 weapon (ge¹)    124

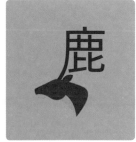
鹿 deer (lu⁴)    125

艹 grass (cao³)    128

貝 shell (bei⁴)    130

小 small (xiao³)    132

鬼 ghost (gui³)    135

勹 to wrap up (bao¹)    136

几 how many (ji³)    138

厶 private (si¹)    140

示 to reveal (shi⁴)    142

干 shield (gan¹)    144

冫 ice (bing¹)    146

欠 to owe (qian⁴)    148

匕 dagger (bi³)    150

# Index of Characters and Phrases

Chineasy teaches mainly traditional Chinese (see p. 11). Where the traditional and simplified forms of a character are different, the traditional form is given first, followed by the simplified form. Where no distinction between forms is noted, the traditional and simplified forms of the character are the same.

## Peter and the Wolf

# Acknowledgments

The entire Chineasy project started out of a desire to teach my own children, MuLan (慕嵐) and MuAn (慕安) to read and appreciate the Chinese language and culture and a personal curiosity to see if I could tackle the enormous task of deciphering the Chinese language of my childhood.

Thanks to Bruno Giussani and Chris Anderson I was given the opportunity to share my private project on the global TED stage with a much larger audience than I ever intended, and I wish to thank Gary Sheinwald, Dario Pescador and Robert Leslie for their endless encouragement, constructive criticism and support during the four-month preparation leading up to my TED talk.

To execute the project I enlisted the help of Crispin Jameson and his Brave New World team, who have done a beautiful job. Throughout this process I also had the great pleasure of working with Noma Bar, whose fascinating illustrations have made my Chinese characters come to life. Isabella Schoepfer's assistance as project manager has been vital. I also want to thank Dimple Nathwani who has been looking after me for the past six years!

I very quickly realized that Chineasy was taking on a life of its own, and as more people have come on board the project has grown even bigger. The endless discussions with Crispin and Noma, designers Darren Perry and Carissa Chan and my research assistant, Vanessa Lu (呂佳樺), about each illustration and every single design detail have become my daily routine and I still bring my 'homework' back to MuLan and MuAn for their 'approval'. It sometimes feels like standing in front of a pair of critical judges!

I would also like to thank Judith Greenbury, who is the reason why I first chose to write a Chineasy book. She is turning 90 years old in February 2014 and I want to make sure that I wish her a happy birthday here.

Throughout the whole project a number of people have continued to help and support me: Myron Scholes, Susan Bird, Lulu Wang, Bill Gross, Chase Jarvis, Tim Ferriss, Stefan Sagmeister, Philip Rowley and the Woo family – to all of you, thank you.

And last but not least, Lucas Dietrich of Thames & Hudson gave me the opportunity to serve those who are willing to go on this incredible journey with me.

I left home at the age of 14, and have run around the world to try to understand myself, and my place in the world, ever since. I have looked for meaning and answers while walking barefoot through the Colombian Amazon, while sleeping in the Botswana desert listening to lions and hyenas, and while pushing myself to the limits of my endurance in some of the harshest, and coldest, climates in the world. After all the searching and fuss I finally realized that the answer to my question could be found where I started – home. I hope my calligrapher mother Lin FangZi (林峰子) and ceramic artist father Hsueh RuiFang (薛瑞芳) can finally stop worrying about me, their rebellious daughter, now that I have found my place, and as I raise my own rebellious children.